Dedication:

For my Mother, who first inspired me with the love of Trees, the beauty of flowers, and the possibility of writing poetry.

And to David Boynton, lover of and beloved by all of the Nature on Kauai.

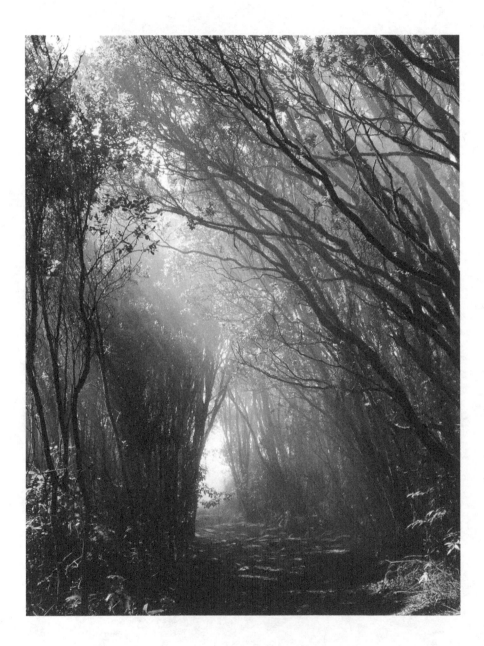

Table of Contents

Introduction

The mist that swirls around me is neither cool nor warm, a fact which enhances my feeling that I am suspended in nothingness. Before me, I know, lies a deep green valley. Around me, I know, trees raise their limbs in the still air, clothed in soft mosses. But for the moment, the mist encompasses all. I stand still and listen, waiting for the whispers I know will come.

I stand in the mountain environment known as Kōke'e, on the island of Kaua'i, in the middle of the Pacific Ocean. Here, as in other places of wilderness scattered around the world, Nature speaks, if you but dare to listen. This book is a distilled essence of the experience of being on the mountain, in the forest, immersed in Nature's Presence. It is a collection of gifts from Nature, glimpses of her treasures, secret messages, magical moments created to delight us, and inspiration drawn from her wonders. Through these, Nature offers to you an invitation to visit her, spend some time and get to know her, and listen yourself for her Whispers.

Nature has always called to me, and as I learned to respond I found that there were many gifts offered to me. I found that there was a healing energy in nature, a balancing, a re-centering, a way to discover a deeper part of yourself, and to feel your connection with the rest of life.

If, for example, I was emotionally distraught over some situation in my life, a walk down long beach, with the sound and sight of surf rolling along the shore, was sure to calm me, to help me step back and look at the bigger picture. If I was over-worked and tired, I would sit in the quiet of the mountains listening to the evening birds and the wind in the trees, and feel the tension and weariness draining out of me. If I was restless and worried and getting too serious about something, a walk on a wild trail was sure to present something so delightful and unexpected that it would have me laughing. Eventually I came to understand that spending time with nature was not something trivial, and not an indulgent luxury, but actually some-thing important to our well-being. The gifts to be found in nature cannot be found elsewhere.

I have brought you a collection of visions, glimpses, hints at what is there in Nature's presence. It is my hope that in reading them you will be inspired to seek out Nature for yourself, for it is in your own one-on-one connection that the wonder lies. As you read this book, and as you wander in Nature's wilderness, I would suggest that you try doing so from a particular mindset. It is a mindset you may not be accustomed to, yet it is found in many places; in some Indigenous cultures, in some Spiritual paths, and in Shamanic viewpoints. It includes the following ideas.

Hold in your mind these concepts:

~ Everything is alive.

~ The elements, Fire, Water, Air, and Earth, are the underlying support of all that lives on this planet.

~ All life has its own type of awareness and intelligence.

~ Interaction and communication between life forms is not only possible but ultimately essential to the well being of the planet.

~ You, personally, are also a part of the intricately connected web of life on Earth. You are dependant on the rest of life, and your life in turn affects other life.

Connecting with Nature is your birthright. You are a part of this world, and the experiences to be found in Nature's presence are a part of your nourishment just as are the water you drink and the food you eat.

The more common mindset of our culture, and the form of our education, have developed in us ways of thinking with logic and reason and seeing the world through scientific attitudes. These are very useful attributes. But there are other talents as well, which we have long ignored, talents waiting within us to be given a chance to grow. One of these is the ability to connect in meaningful ways with the natural world, to interact on a level of intuition and sensing, to receive the gifts of beauty, spaciousness, and unexpected wonder.

When you go to Nature, go not only with an open mind, but also with an open heart. Nature will delight in your coming, and there you will find joy and love to be shared. Happy Wanderings!

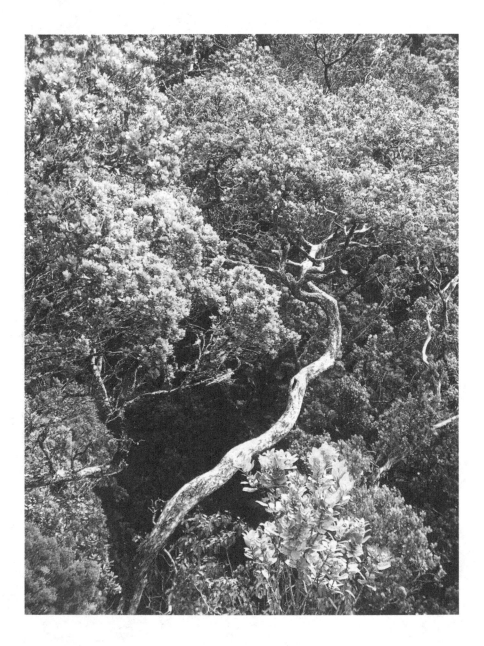

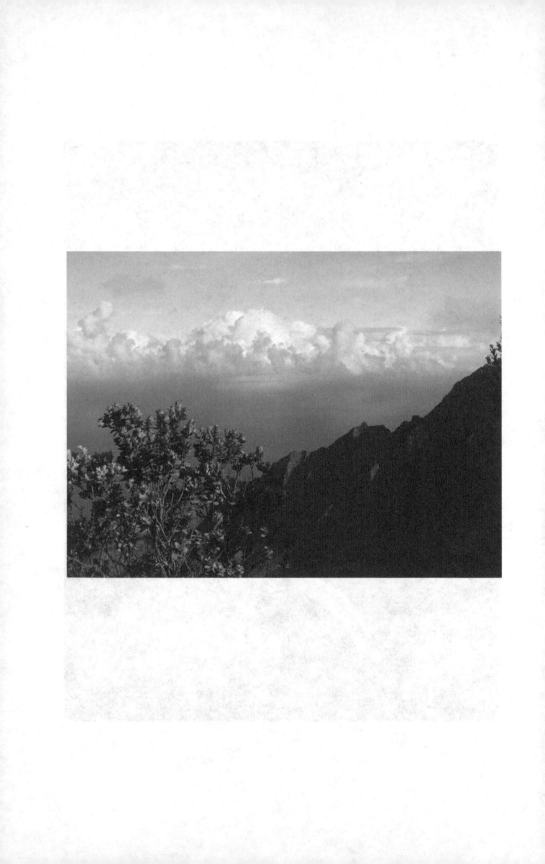

Moments of Wonder

It almost seems a lost art these days, to have a sense of Wonder. Viewing the world with wonder means to be open to the "amazingness" of Life, to have a sense of Awe, to acknowledge that there is a deeper Mystery at work in the world than we are, or ever could be, fully aware of. Walking with wonder means to appreciate that Nature is vibrantly alive and ever creating. Nature is ever devising new patterns, new combinations, new interactions, new variations, and an un-ending stream of magical moments. Walking with a sense of wonder means to be present with an open heart, to be receptive, to allow nature to touch you.

Wonder carries you into timelessness. When you see a breathtakingly beautiful vista or are stopped in your tracks to marvel at the amazingly intricate pattern on a leaf, or the way light reflects off a pool of still water, it is as if you are suspended, standing in between moments of ordinary time. Nature's creative ability is so as-tounding. I can walk the same trail fifty times, and know that each time many things will have changed and I will see something new. I ask myself, "What did Nature arrange for me to see here today?" It's like a treasure hunt, and I am never disap-pointed.

One of the problems with hanging out only with other humans is that as a species we tend to be fond of order and patterns and rules. Now, there is nothing wrong with these things, and we need them in our lives, but to have them exclusively leads to things being too predictable and uniform. We need also to experience the unexpected and delightful. Nature, if we leave her room to operate, provides these for us. Nature feeds our Spirits with Wonder.

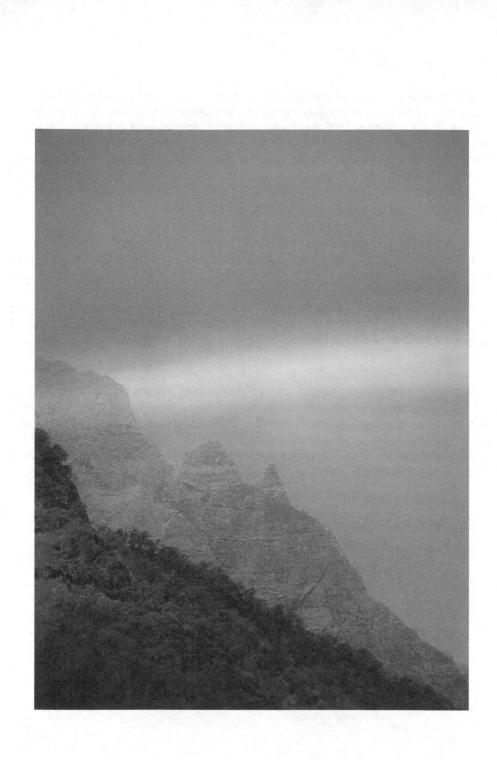

Just the smallest step away, in this very moment,
there lies another way of being, another way of seeing
the world that lies around you.
Just the smallest blink of an eye,
or perhaps it is the blink of a heart,
and everything around you comes suddenly alive,
to a new and greater depth.

Suddenly you know
what a miracle it is that there is life.
Suddenly your heart connects to this tree, or that mountain,
or the fragrance of a delicate flower,
and you step into the world of Wonder.
You step into a sense of Awe
that this most amazing thing could exist,
and that this most amazing thing
is just as alive as you are.

You go around a bend in your path
and the view that lies before you there
takes you away beyond space and time,
and for a timeless instant you feel yourself being
that very valley, that ocean, that forest that you gaze upon.
There is not you and the view.
There is just the Beingness of which you are a part,
melted seamlessly together.

You step into that place of connection
with some Being of the world of Nature,
and you cross over the threshold,
partly into their way of perceiving.
From the worldview of humankind,
where the separation and delineation between us is strong,
you cross to that world where connection is stronger.
You cross into knowing a feeling of being not just this tree
but this tree of this grove of this species
of all trees of the plant kingdom,
all woven together.
You become aware that what you share
is the presence of the One Spirit,
around you, inside you,
there Being each of you.
And then you are walking
in the Way of Wonder.

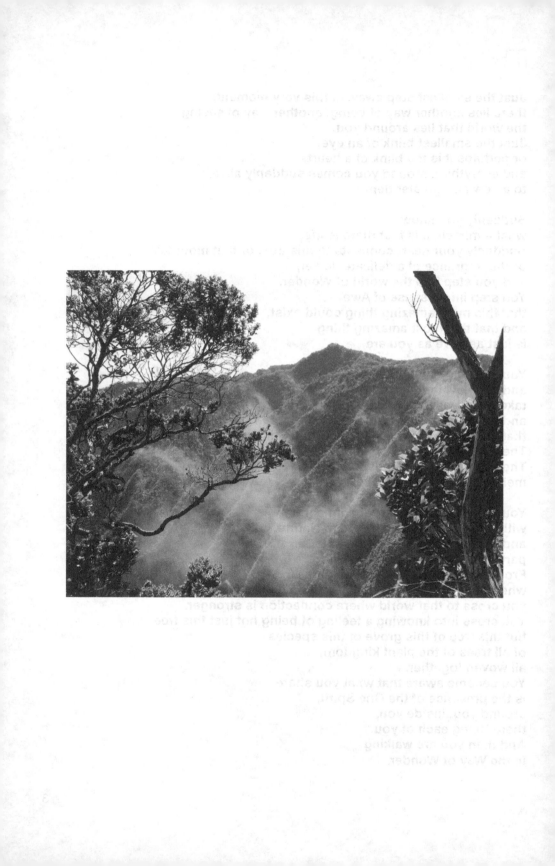

Mountain Sits in Stillness

Cloud hangs over the top of the mountain.
Mountain sits in stillness.
Cloud slowly moves away.
Mountain sits in stillness.

Cloud drifts and swirls,
at mountain's peak
and down the slopes,
coming, going,
creating a vision of changing shapes,
creating a mood of mystery.
Mountain sits in stillness.

Caressed by cloud,
or standing alone,
Mountain is calm and still,
watching changes come and go.
Mountain knows
that all is well,
in each moment perfect
for that moment.

Cloud dances, and teases,
and plays with mountain.
Mountain sits in stillness,
And smiles.

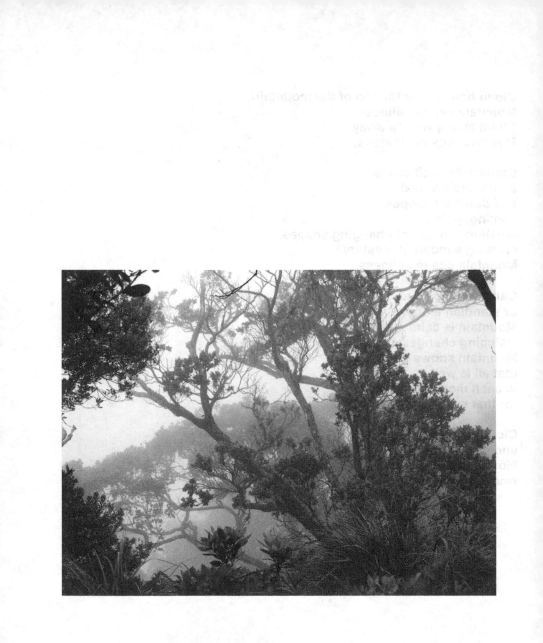

Standing in a Cloud

I am standing inside a cloud,
within a cloud forest,
tall trees raising their arms in silence,
as soft grey mist settles down around us all.
Such a strangeness in such a moment,
an other-world-liness,
an in-between-ness,
like standing on the brink of nowhere-ness.
In every direction,
everything fades into grayness,
and swirls of mist materialize and then vanish.
No wind. No movement in the trees.
It feels as if reality is hovering,
trying to decide
what to become next.
Perhaps I too am hovering,
trying to choose
the next right step for my life,
hovering somewhere between
what was, what is,
what almost could have been,
and what might just possibly be coming.

This cloud is a paradox.
I know moisture fills the air,
the trees are dripping with it.
Yet I hold out my hand and it feels dry.
My visibility extends only the smallest distance,
I see only what is right around me,
yet I feel I am looking into eternity,
for I am looking into
the vast potential of Mystery.

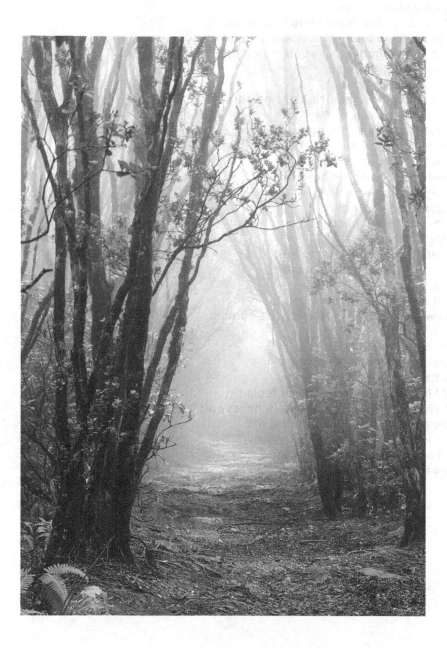

Walking in Pihea Clouds

Here do I stand,
on the edge of Mystery...
Swirling mist fills the path before me.
So delicate I scarcely can discern it's touch,
it is yet powerful enough
to hide all from my view.

What changes have been brought
by this magical moment
of the presence of the mist?
The birds sing different songs now,
and the trees speak only
the slightest whispers.
If I step into the mist
will I too be changed?
Will the path carry me into other realities?
Will walking in Mystery nourish my soul?

How very strange it seems
to stand and gaze toward a well known view
and see........nothingness.
Is what I knew still there, but hidden by the mist?
Or is it gone?
Which is reality?
When the mist leaves,
will it be the same as it was before?

And if I were to step forward
and walk through this magical mist...
Is it really that I walk through it?
Or does the mist blow through me?
And when I return,
will I be the same as I was before?

I must have returned,
for here I sit writing.
But how has it changed me?
That is difficult to say,
for such things do not come easily into words.
So I say only this:
Go and walk through the mist of Pihea.
Step into the Presence of Mystery.
Only then will you know.
Only then will you touch upon Wonder.

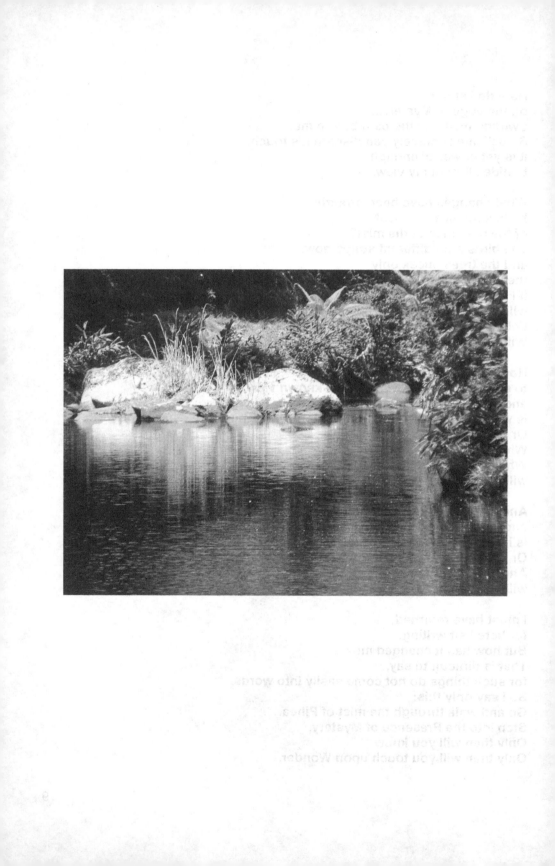

Touched by Winter Sun

Winter sun warms me,
Sitting on boulder,
Softly sings
the flowing stream.

Dragonfly skims
the surface of water,
Wonder fills
this living dream.

Treetops whisper
to breeze that caresses,
Sweetest fragrance
fills the air.

Bird and flower
give thanks for creation,
Every form of life
is aware.

Formless Spirit
here dwelling in matter,
Lives in all
the Life around,
Holds the dreaming
that brings forth creation,
Giving breath
and giving sound.

So I sit here
blessed beyond measure
As is all
the human race,
Given Life
from Divine Spirit,
Held in Nature's
sweet embrace.

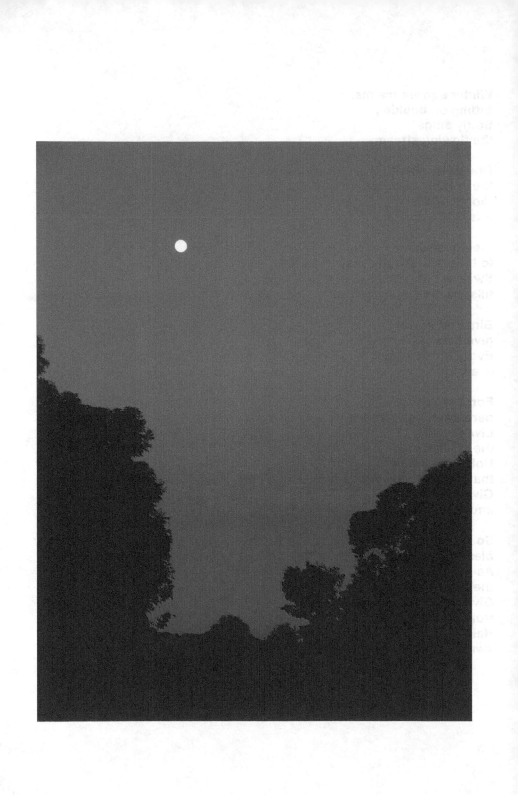

Moon on the Mountain

On the mountain
the night is deep and soft;
gentle silence,
textured only by an occasional murmur from a tall tree,
cool clear air,
slightly scented by cedar smoke,
dark deep sky,
sprinkled with stars and drifting clouds.
I slipped easily into sleep.

Somewhere in that vague time of
"middle of the night,"
I was awakened by a touch
of golden light upon my face.
Mahina Māhealani,
a full, golden, shining moon
hung in the sky above the tallest trees.
I smiled, delighted that these wide windows
would allow me to watch her passage
across the night sky,
from high overhead,
to her dawn setting in the west.
A wisp of an old song drifted through my mind,
something about "moonlight on your bed."
And I dozed back into sleep.

Often I have watched the moon's passage overhead
as I slept off and on in a small tent.
Now also, every little while I would wake again,
looking out to see how far the moon had traveled.
Each time I would watch awhile,
entranced by her beauty.
Sometimes she flirted with patterned clouds,
other times stood full and round against the sky,
her light so bright
I could see around the cabin with ease.
Again I would doze and awake,
sometimes singing a song for the moon,
or a chant to Hina,
as they came into my mind.
As she neared the horizon, her color deepened,
warm gold to nearly orange,
and she appeared to grow even larger and even fuller.
So too deepened her beauty
and her sense of magic.

I could remain in bed no longer.
Wrapping in a warm robe against the cool air,
I went outside to be with the moon.
To see this huge, round, soft, warm, bright, golden light
hanging in the now deep indigo pre-dawn sky
fills me always with a sense of awe and wonder.
How can this be?
How is it that such a moment of beauty is created?
Does the moon know what wonder she stirs in our hearts?
Is she smiling to herself at her effect on us?

Oh so slowly, she began her descent into the sea,
shining her golden light onto a small cloud hanging above her.
Finally with a fiery wink, she was gone.
Until tonight.
I will be waiting, Mahina.
Wake me again,
to share your wonder.

Let Yourself Be Touched by Wildness

It often takes two days to really get there,
and that's after you've parked the car, stepped out,
and drawn your first breath of wild forest air.
You set up camp and start to explore,
but part of you is still back in that other world,
stuck in the rush mode,
the thinking mode, the analyzing mode,
the how-many-things-can-I-pack-into-this-afternoon mode.
But you know you want to get "there."
There, to that place where you can feel the breeze so gently on your skin,
notice that the shadows have moved from there to here,
and feel the wave of deep peace
that the trees are sending to embrace you.

We spend so much time in a high-energy static,
society frazzlement, I call it,
that many people think it is normal,
and some use it as a drug, addicted to it.
But deep down, we know it is unhealthy for us.
It may have its uses, in short doses,
in terms of earning a living and surviving in the modern world,
but such states of mind were never meant to be our default way of being.
And when we really look at it,
we sense that it is covering over something deeper within us,
something primal,
and timeless,
and absolutely essential to our real Being,
to the life of our Soul.
So we come,
if, hopefully, we know to do so,
to the Wildness.
For Nature has the antidote.
Slowly she begins touching us,
combing through us,
undoing the tangles, so we can float freely and softly and easily
Like easing ourselves into a cool lake,
oh, so, slowly,
we immerse ourselves into the underlying oneness
of the Life surrounding us.

The truest things in this world seem to live as paradoxes,
and one lies here.
In the crush of busy society we are the most isolated,
each drawn tightly into ourselves,
wearing our ego's image as our clothing and our protection.
But here, alone, in the Wild,
once you really, finally arrive,
you can let down your boundaries and melt into Being,
being who you really, deep down, are.

We all have those first reactions,
coming to a place of wilderness.
There is so much to see, so much to do, so many ways to play.
But as you cycle through them, just keep pausing,
keep breathing, sinking deeper, slowing down.
Nature will help you,
she always does,
if you just stay long enough to let her do her work.
And then, in some unexpected moment,
you'll know that you are finally there,
that something inside you has opened,
something has been healed.
And then you will know,
that you have let yourself be touched,
by the Wildness.

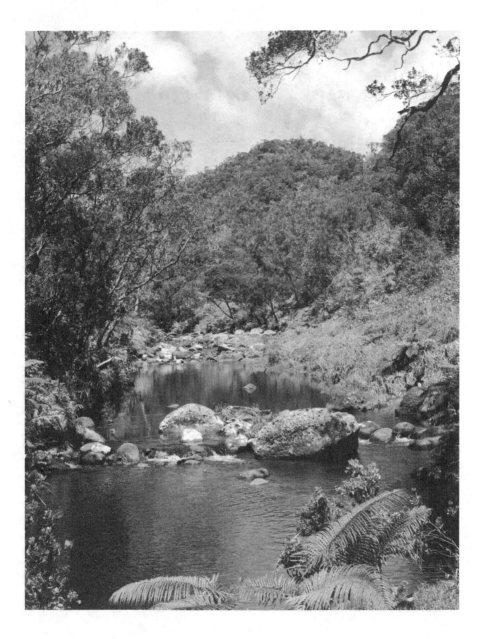

A Thousand Tiny Caresses

How is it that she touches me,
this wondrous presence of Nature?
So subtle and so powerful,
like a thousand tiny caresses,
which come not only as touch
but in sounds, in fragrance,
in delights for my vision…
Nature's gifts are abundant,
welcoming me into her presence
each time that I go to her.
I step away for a while
from the human focused world
and allow myself to settle
quietly into nature's embrace.

Wind blows through the treetops,
leaves dance and shake and rustle,
and are refreshed with a new energy.
I call for the wind to blow also through me,
through my heart and mind and body.
I breathe in the sound,
and I feel it breaking up the tensions,
releasing them so I can let them fall away.
Gradually, they do.
Upon my face I feel the play
of warm sun and cool shadow
as I walk through a grove of 'Ōhi'a trees.
These gentle and most soothing touches
carry the message that I am loved.
A vibrant song fills the air
and I know a Shama is near.
I stop still and look around.
There, on a small branch,
right at my heart level,
she sits and stays long
to let me have a look at her.

So many ways does Nature have
of touching me when I walk with her…
…riversong that rises around me,
 bubbly and gurgly and full of texture,
…the gentle mist that settles softly on my hair,
…the fragrance of wet cedar that embraces me,
…tall grass that swishes against my legs,
…curve upon curve of crescent leaved Koa
 that somehow soothes my heart,
…an unexpected blossom that brings me delight…
Each sound, each fragrance, each surprising sight
eases away tension,
removes weariness,
settles confusion.
In Nature's arms I am gently held,
nurtured, healed, and renewed.
And all the while,
with little bits of wonder,
she feeds my Spirit.
A thousand tiny caresses
she has given me,
and now once again,
I can smile.

So quietly she speaks, so gently...
The barest whisper in a breeze,
and a thought that lightly brushes against my mind.
She knows that when I first come to her,
I am not even ready to listen.
And so, patiently, she eases away my tensions.
Her gentle mists embrace me,
dissolving the frazzlements
I've somehow collected around me.
She catches my attention
with blossoming flowers and uncurling fern fronds,
until my mind finally gives up its chattering preoccupation.
And then, when I am finally ready to hear her voice,
she sends me messengers
with whispers that touch my heart.

Slow down, she urges.
It is not good to be always in a hurry.
Stop, and be still for a moment.
I lean upon my walking stick,
and gaze down into the valley far below.
There, against the steeply rising cliff far down to my left,
is a waterfall I had never seen before.
Sunlight catches the wings of a pair of white tropic birds,
as they circle gracefully near the water.
I listen, and am surprised that even from this great height
I can hear the sound of the river flowing down the valley.

Another movement catches my eyes,
again far below,
and I see the distinctive shape of a pair of owls,
spiraling upwards.
They are soon obscured from sight by trees and shrubs
jutting out of the valley walls.
I send them a silent "Thank you,"
for I am always delighted by their presence.
I begin to notice the changes within me,
how good it feels just to be here
in this moment of stillness.

I look off to my right,
to the tall dark green ridges now catching the sunlight,
with all their folds and crevices outlined by shadows.
At their uppermost edge a blue aura of energy
shines against deeper blue sky beyond.
Then, unexpectedly, silently, slowly gliding right in front of me,
is the owl I had seen before far below.
A Pueo.
He is close enough for me to see the pattern of his feathers.
He does not use words,
but the message is there nonetheless,
"See what a little patience will bring?
Remember the value of stillness."

Slowly I resume my walk, reflecting.
Here all around us, is our mother earth,
patiently waiting for us to come to her.
Here in Nature's world are countless magical moments
that will feed our Spirits.
Here in Nature's embrace lies the cure
for so much of our human stress and turmoil.
Time here in the stillness
can balance our overly busy human preoccupations.
The Spirit of Life dwells not only within us, as humans,
but also in nature's countless forms of being.
And here, through the mountain, the forest,
the mist, the sparkles of sunlight,
offers us this most precious gift.
Here Spirit whispers to us,
through the patterns on a leaf,
or the fragrance of a flower,
or the caress of a warm breeze.
Here we are given messages, reminders,
encouragement, delight.
But first we must come,
and slow down,
and be still,
and listen.
Only then will we be able to accept the gift.
Only then will we hear
the whispers on the mountain.

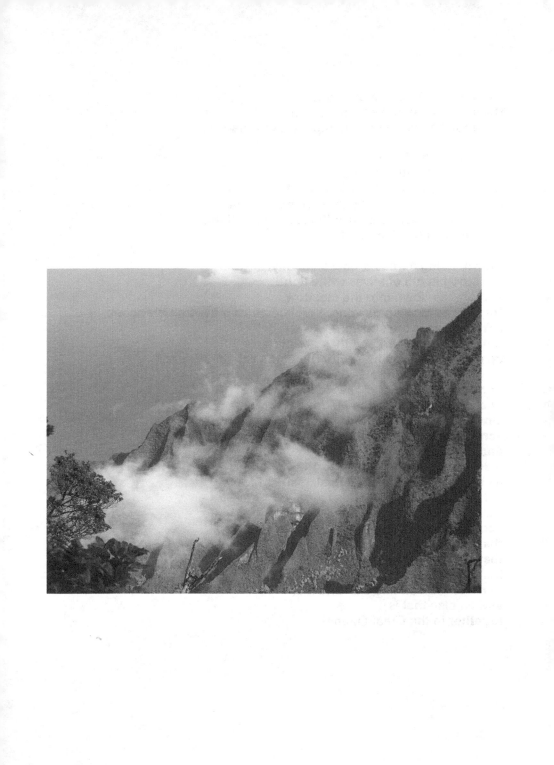

Night of the Red Moon

October crickets in a drizzly rain,
the air is still unseasonably warm.
Time for one more deep immersion into nature.

The Earth, the Moon,
the reflected Sun, and Me,
the drips of rain that fall from the trees,
the cricket song, and sounds of the stream,
together are weaving the stillness of this night,
to form a magical moment.

Slowly rising across a now clear sky,
the Moon is full of silver-white light,
and shines down into the meadow.
Huge raindrops sit glowing, perched among the tree branches,
left there after the shower,
but then again, perhaps they are fairies,
so disguised to be here with the moon this night.

For this is the night of the Red Moon.
The Earth will touch the Moon tonight,
slowly sweeping her shadow
across the surface of the full moon,
and where they touch,
a deep red glow will shine forth,
as some alchemical, mystical, magical force
is born of their connection.

I come here tonight,
that I too may join this connection,
that I may again remind myself
that always we are connected,
Earth and Moon and Sun and Me,
and all else that is,
together in the Great Oneness.

Some hours pass,
the moon is now overhead,
a pale orangey-red instead of silver.
And then a deeper shadow comes,
the deepest red creeping slowly across her surface,
until she is so dark,
she hardly stands out from the night sky,
and the stars all around her
shine brightly in the dark night.
The earth holds the moon in a shadow embrace,
and they slip behind a cloud.

Again time passes,
and though it is yet well before dawn,
I look across a moonlit meadow
now so bright it could almost be daylight.
Now the moon touches the earth,
again sending silver white light
to caress every tree branch and blade of grass.

All of this wonder,
in a single night.
I am so glad they shared it with me.

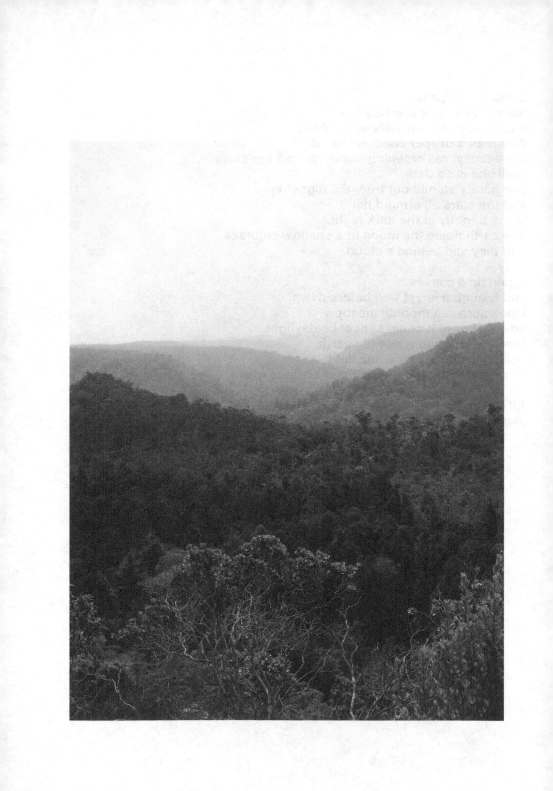

What is it that happens out there?

What is it that happens out there,
when I go to wander all day in nature's wild places?
It is as if I am fed,
when I knew not that I had a hunger.
It is as if I am healed,
when I knew not that I was ill.
My ears respond with relief and delight
to a sound that is mostly silence,
and my body cherishes the touches
of wind and sun and mist and even rain.
I feel at home there,
wandering places I have walked countless times,
and yet every time it is different.
Wildness lives there,
living, growing, shifting,
moving through cycles and seasons and weather patterns
to form combinations of endless variety.
A swirl of fragrance drifts by,
sunlight sparkles off a perfectly poised raindrop
lingering on a leaf tip,
a dragonfly circles around me,
and a delicate moss presents yet another shade of green
that I had never seen before.

Feeling chilled from the rain,
I suddenly feel the urge to go stand near a large tree.
Without even touching the tree,
I feel warmth flowing into me.
Half an hour later, it happens again;
I feel cold and tired, and stop for a few moments
standing next to a tree.
Again I feel warmth and energy flow into me.
Don't try to tell me its impossible.
Out there in the wild, logic doesn't stand a chance.
My own mind tried also to deny that it could be so.
But I felt it. Twice.
The trees were giving me a gift.
They knew I would accept it.

What is it that happens out there?
Something shifts.
Some human created barrier
that normally surrounds my perception
seems to dissolve away,
and I see so much more of reality's possibilities.
Even so, I sense I am only seeing
the smallest glimpse
of the layer upon layer
of wonder that IS.

What is it that happens out there?
I so long to share it with you,
so that you too will go out to seek it, feel it,
experience this wonder.
But how can I put into words
that which is timeless, formless,
and beyond language to express?
So it seems there is only one answer.
Go there.
Feel it.
Because what it is
that happens out there
is something not to be missed.
What it is
that happens out there
is the essence of Wonder.

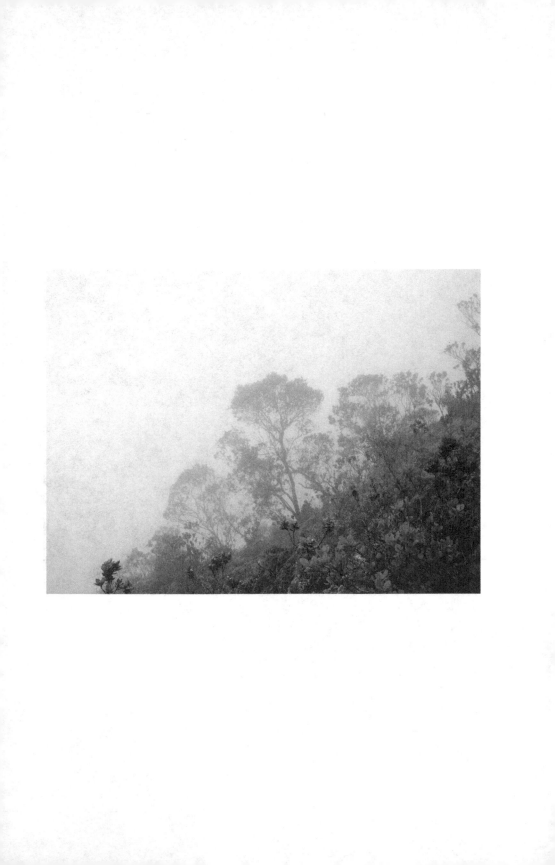

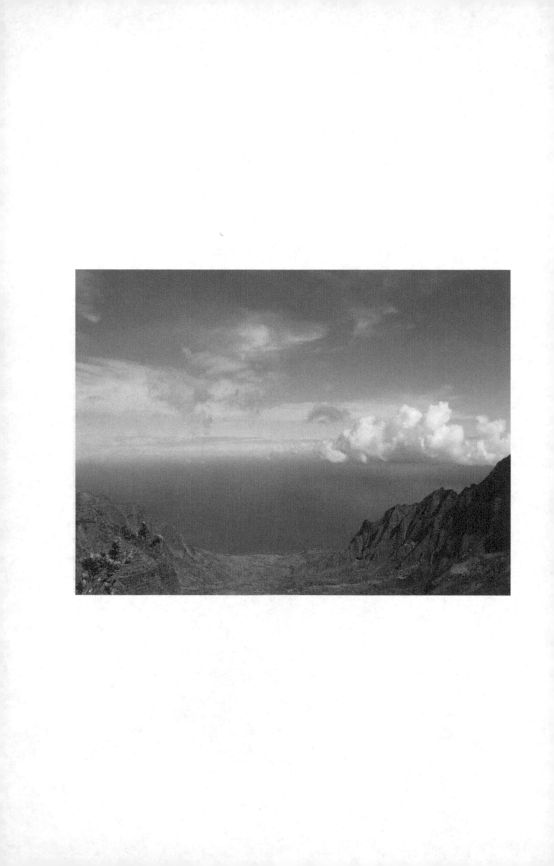

The Elements

The very foundation of life on our planet lies with the Elements, the four elemental powers that support all life. Yet how little we think or speak of them in our modern culture. Fire, Water, Earth, and Air. Without them we could not exist. Whatever lives, every plant and animal and human, depends on these for survival. Yet how often do we acknowledge them, or thank them for their gifts?

Sitting before a campfire you put another log on the fire and perhaps are glad for the warmth and beauty. But wait a moment, look at that log before you put it on the fire…. for how many years did this tree gather sunlight into its leaves creating the nutrients to make the wood that now releases this captured sunlight energy for your use? And fire is something that we depend upon not only at an occasional campfire, but daily in our ordinary lives. Usually it's form is disguised so that we don't think of it as fire, but every use of coal or oil or gas or electricity is really an altered form of fire energy from the sun. Every hot shower that you take, every meal of cooked food, every time you drive in your car, you are using fire.

Water we usually are a little more connected with; we drink it and we bathe in it. But again it pervades our lives in so many ways that we normally don't consider. For example, how many of the variety of beverages that you drink are really mostly water?

Water enables plants to live, and so you may have a lawn, trees, flowers, a bowl of lettuce, a handful of nuts. All of the elements, in fact, play hidden roles in everything that touches our lives. Every mouthful of food we eat comes from sources dependant on them. The manufacture of every product mankind has devised uses one or more of the elements in its processes.

Instead of taking them for granted, try opening your awareness to the presence of the elements, at least in the ways that you can experience them directly. Take note of the song of a bird or the fragrance of a flower, and remember that it was carried to you by the Air. Sit in the shade of a tree and remember that it is Earth that holds its roots and enables it to stand erect as well as bringing it nutrients. Listen to the rain and know that the forests and the flowers and the food crops are all happily drinking it in. Look at the beauty of early morning light and be grateful that every single day the earth turns toward the sun to bring us the cycles of darkness and daylight.

Look for ways to become closer to the elements, to feel them, enjoy them, get to know them. You are alive, on this most amazing planet, supported by the presence of Fire, Water, Earth, and Air.

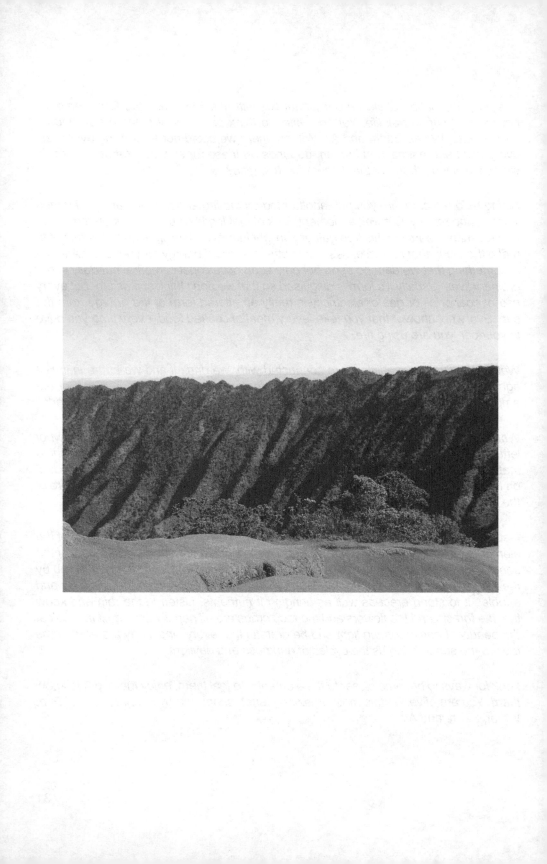

Five Strands of Wonder

Five strands of Wonder, woven together.
Five strands of wonderous Being,
ethereally wrought in some timeless moment,
from out of the Great Mystery.
Woven together so delicately, so magically,
that they became the Life of this planet.
Now they infuse and maintain it,
moment to moment, endlessly.
These Five Powers are at once
infinitely strong and infinitely gentle,
moving in a delicate balance that supports them all,
as they continue to re-create this world.
Five Elements, whose essence flows
around and within and throughout this planet,
form the underlying support enabling its existence.

Casually we toss their names about
as if we knew them well;
Fire, Water, Earth, Air, and Nature.
Yet in those rare moments when we dwell
on what they truly consist of,
their essence is strangely elusive,
complicated, magical, and hard to pin down.
We would be hard pressed to explain them
to one who had never experienced them.

They are strands of wonder,
of mystery, of awesome abilities,
woven together
to create a living and livable planet,
and all that lives upon it.
By their Presence here,
are we able to exist,
and we are truly blessed.

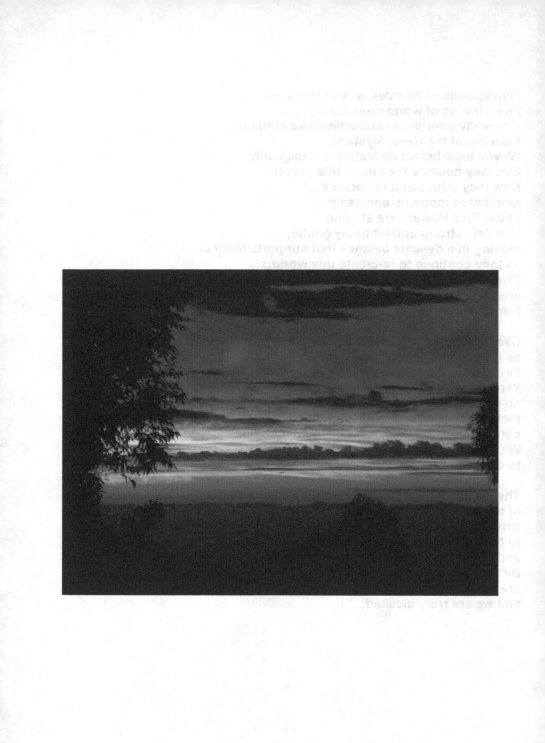

FIRE

Burning heat. Brilliant light.
Energy, in changing forms.
Passion and desire.
By your flame we are drawn into mystery and wondering,
and in your crackling you speak to us
in a language we somehow understand,
but never could translate.
Fire, bring me warmth. Heal and transform me.
Teach me wise use of power.

WATER

Fluid motion. Graceful.
Flexible. Always changing.
No obstacle stops you,
for you merely change the shape or form of what you are.
How long it takes doesn't matter,
For you are familiar with eternity.
We drink of you, and so have life.
Water, teach me persistence, flexibility,
how to flow as gracefully as you do.

AIR

Here, and yet unseen,
though I know your touch.
You fill my lungs, that I may live,
and with your movement come many gifts.
Coolness. Moistness. Fragrance. Sound.
Your touch can be one of gentle playfulness or violent fury.
Air, Stir up my ideas,
carry to me a new and novel inspiration.

EARTH

Fertile Mother, nurturing me.
You bring forth the beauty that feeds my soul.
Food and shelter you bring for my body, and wonder for my heart.
Solid and strong, you uphold me, that I may stand.
Earth, show me the way to be both strong and serene.

Dance around me, Spirits of the Elements,
That I may learn to live in harmony with you.

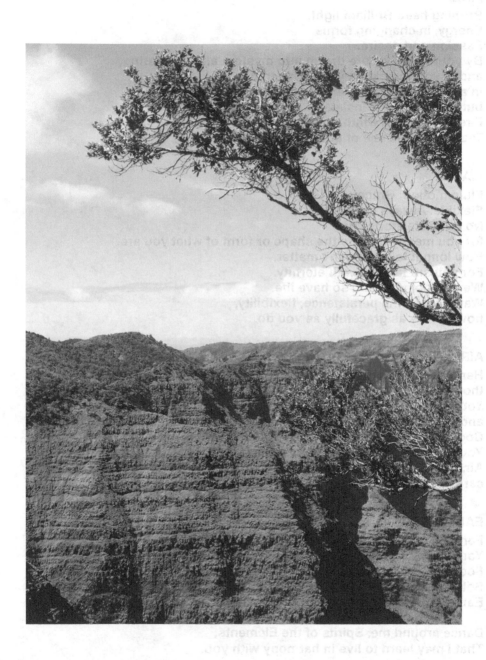

Mother Earth, Father Sky

Mother Earth, Father Sky,
how magical this love you share.
Your sweet caresses come in the form of breezes,
blowing back and forth between you.
The spirit of your Love manifests as the water
given from Sky to Earth, as rain.
For a while it flows around the earth,
caressing her, as stream, river, and ocean.
Then this water of love is given again,
from Earth to Sky, as evaporation.
For a while it floats around the sky,
caressing him, as mist and cloud.
And then the cycle repeats,
ever and ever again.

Born of your love, Father Sky and Mother Earth,
what wonder-filled creation.
The plants, your daughters,
express their delight in countless forms;
tall singing trees, softly swaying grasses,
delicate intricate ferns, lush vibrant mosses,
and flowers offering endless variety
of color, fragrance, beauty.
And your sons, the animals,
express their boundless energy, delighting in motion,
with again such diversity;
the stately heron, the sparkling dragonfly,
the laughing dolphin, the swift running antelope,
the wiggling earthworms, and the tall black bear.
A long time you played with these, your children,
nurturing them, loving them,
allowing them to grow and express their uniqueness.
And when they were ready to help care for a younger child,
then were brought forth the humans.

How fortunate we are to dwell in this place,
for here we are caressed by your breezes.
Here we are touched by your water of love,
And here we are nourished and assisted
by our brothers and sisters,
the life who shares this world with us.
Father Sky, Mother Earth,
how glad I am
that you fell in love.

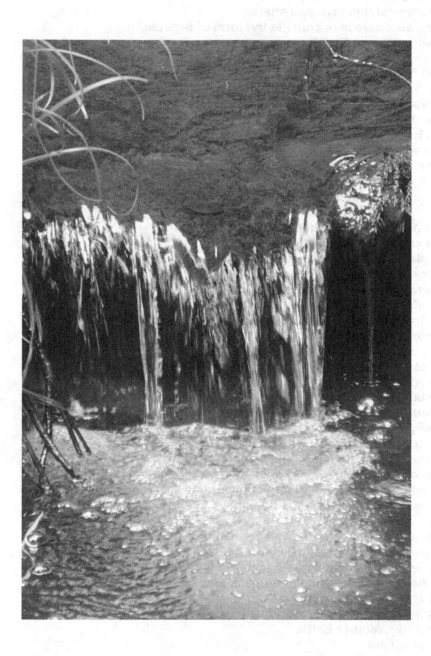

Waterflow

Silver sparkles
hanging in mid-air,
blowing, swirling.
Mist in the mountains,
cloud visiting forest.

Sliding down trees,
tiny droplets gathering together,
nourishing mosses,
washing the ferns,
soaking into earth,
rain giving life.

Rivulets forming,
seeking lower ground,
wiggling and winding
their way to each other,
water starts to flow.

Vibrant streamlets
laughing as they find their way,
leaping and dancing,
crawling under boulders,
sliding over pebbles,
finding their way into streams.

Wide banks, deep pools,
sunlight sparkling on the surface,
often moving slowly
but holding much power,
and a home for water creatures,
River is majestic
and the bringer of many gifts.

The goal of a long journey
now within sight,
deep rumbles of offshore surf,
water enters ocean,
sliding over warm sand,
merging together salt and sweet,
now to be waves and swells
and deepest blue sea,
sinking into cold depths of mystery
to rest for a while.

Full moon beckons to the water,
calls her out to move and sway
and fashion reflections
of silver-golden light.

Sunlight warms the ocean surface,
teasing, calling water to awaken,
remembering a different life
long ago lived away from the sea.

Some droplets respond,
magically flying up into the air
to live as vapor, cloud, and mist,
and find their way home again,
back to the clouds
at the top of the mountain.

(E ho'o mai ka'i i ka wai
Blessed be Water)

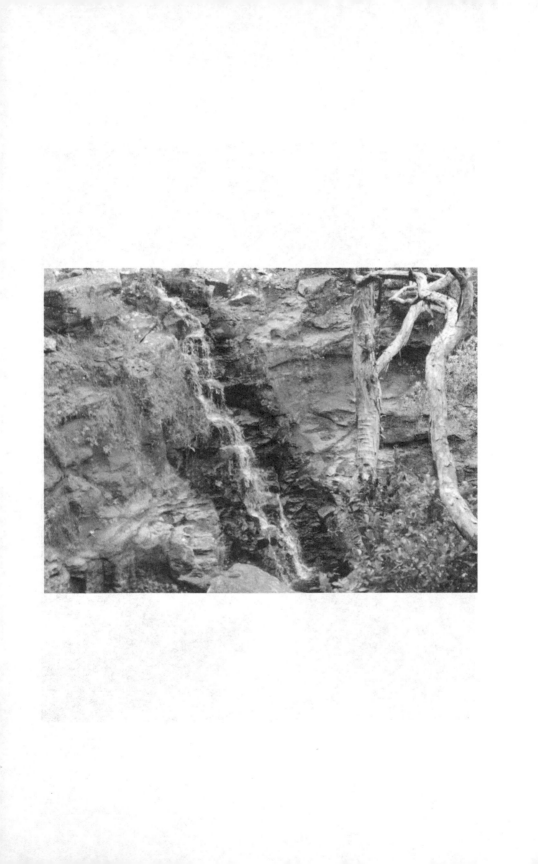

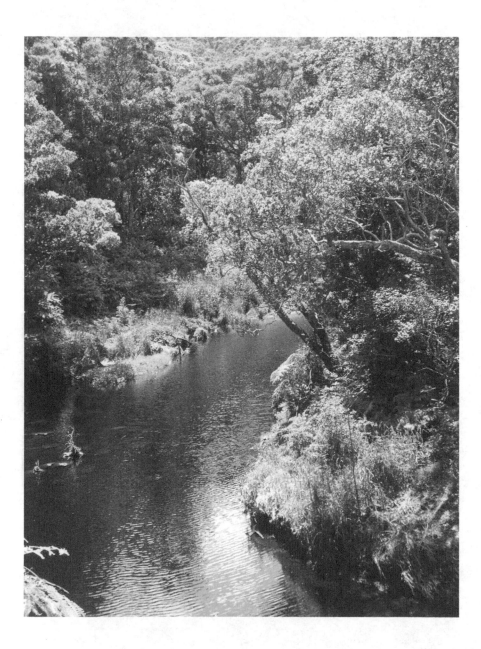

Sparkling Stream

The Stream called to me
from across the wide lawn
nearly as soon as I arrived at the cabin.
"Come, its been a long time
since you have come to visit me."
I ducked beneath the two tall redwoods,
and on her bank I chose a large boulder
on which to sit.
The water was low,
but enough still flowed to sparkle
in the late afternoon sunlight,
and drop between the river rocks
with a lovely song.
I looked down through clear water
to the leaf litter and silt below.
How is it, I wondered,
that this water can flow
over all that muckiness,
and still remain so clear?
Reading my thoughts,
the river answered.
"You have to be willing
to let the silt settle out.
You can't go around carrying it with you,
churning it up over and over again.
In your own mind,
all those little particles of negativity and frazzlement,
of doubt and anxiety,
they're like your silt.
Let them go, let them fall away from you.
Let yourself be light and sparkly,
and flow above them.
Leave them behind."
And then the stream laughed,
and danced in a sparkle of sunlight
as she slid over the next boulder.
I think perhaps
this little stream is wise,
and I would do well
to follow her example.

Rain, Rain, Play today

If I had to give a name to today,
it would probably be "The Rain Sampler."
The day began with cloud,
not just overhead,
but filling all the space around me.
Moving on through the day,
there was light drizzly rain,
wet drippy rain,
singing in the trees rain,
pounding on the roof rain,
soaking into the ground rain
that made the trees happy,
barely discernable rain that
let the birds come out to feed,
rain that formed running streamlets,
rain that blew sideways in different directions,
rain that fell so straight and steady it was almost hypnotic,
rain that teased me into going outside to gaze into it,
rain that came dressed in swirling mists,
and rain that made me glad to sit before a warm fire.
Thank you, rain, for keeping me company today.

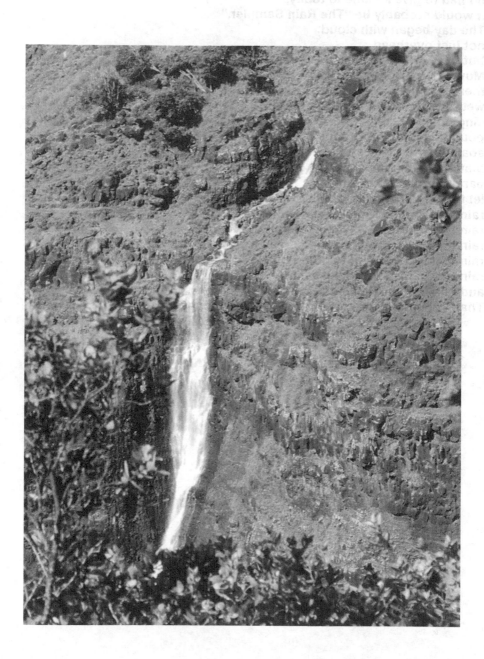

Abundant Water

Water,
falling water, flowing water,
water that falls from the sky,
and falls and falls and falls....
It rained all day yesterday,
misty showers to heavy rainfall.
It rained all night.
Six times it got loud enough to wake me.
It rained all day today,
moderately heavy to outright downpours.
How can there be so much water?
Where does it all come from?
Half my life I lived beside Kai, the Sea,
but never before have I known so much Wai, fresh water,
bringing green upon green upon green to the hillsides,
soaking the happy feet of the wild gingers,
and making the bamboo sigh with delight.
Mahalo, e ke Ualani.
Thank you, heavenly rain,
for your gift of life,
for sparkling clean-ness, for newly washed trees,
and great pools in which to play.
Thank you for quenching the thirst
of all of earth's creatures,
animal, plant, and human.
Thank you for creating the beauty
of tall waterfalls and brilliant rainbows.

Thank you for all the gifts
that Abundant Water brings to our lives.

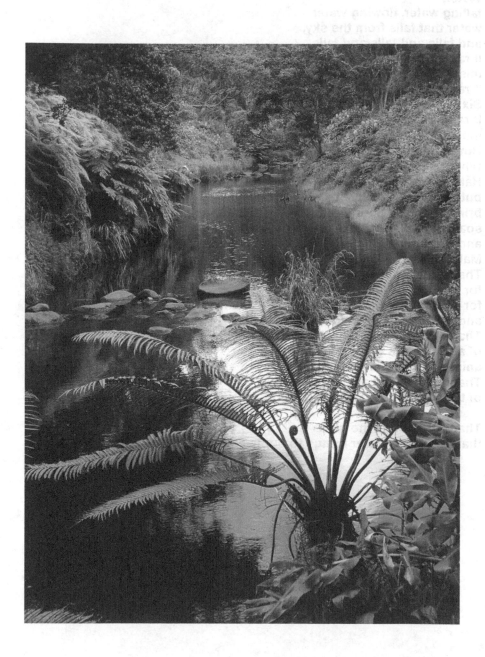

Watching River Flow

Movement and Stillness.
Flowing and Resting.
There between the boulders,
the water comes to smoothness,
reflecting light, breathing slowly.
But the stillness is not only stillness,
for it contains movement.
Slowly the river flows into the quiet pond
and it seems to be still.
Yet there, at the forward edge of the pond,
there in the corners, just below the surface,
flow two moving streams of water,
dancing with new energy,
and ready to flow on through the river's adventures
toward the sea.

How wise, this river,
that it knows to take the time and space
to rest now and then.
In this time of stillness,
it greets and reflects all the life
living upon it's banks.
In the time of stillness,
it absorbs the energy of sun,
sitting still enough
to feel the wispy touch of wind.
In the time of stillness,
it thanks the rocks for holding it,
and thanks the One Great Spirit,
that it is here, being river.
And then river knows
that it is time to dance again,
time to flow and Be River.
It knows that stillness alone breeds stagnation.
There must also be motion, if river is to live.

If I sit here with river,
if I watch, and listen, and learn,
just perhaps, I too
will come to be as wise as river.

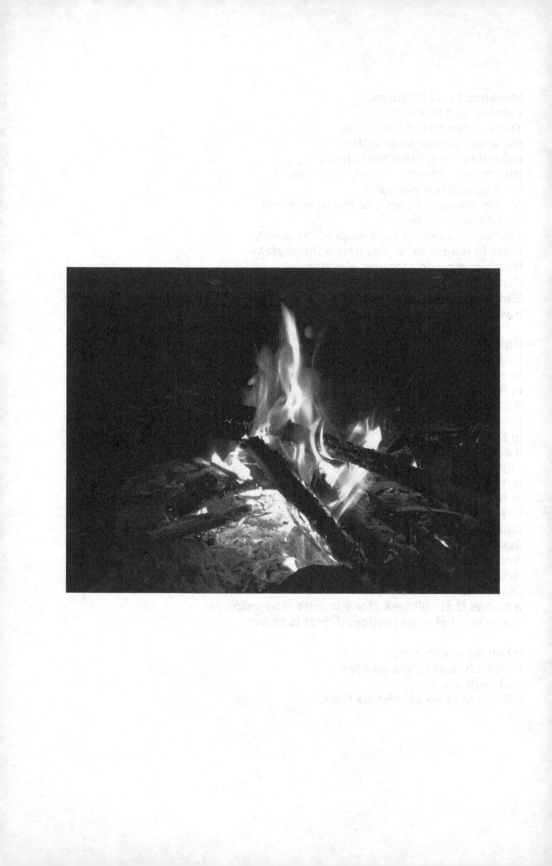

Fire Night

Firelight and silence
fill the winter evening on the mountain,
and fill my heart with quiet contentment.
To sit and simply watch the fire, all else put aside…
such a primordial pleasure, so deeply satisfying,
yet how seldom do we indulge ourselves
with spending time to be with fire.
Here in the fireplace or firepot
is a living work of art.
It dances, leaps, and twirls.
It sings, with crackles and pops and hisses and sighs.
It paints with un-namable shades of yellow and orange,
opaque or translucent flame,
and glowing embers peeking out from inside logs,
moving about as if they played hide and seek.
Firewarmth seeps into my body,
bringing a pleasant drowsiness.
With my poking stick I turn the logs,
add a new piece, move some embers.

Well, yes, fire does take more "work" than
our modern forms of central heat.
But it gives back more too.
Fire gives beauty, comfort, companionship.
In a sense, it's a lot like other relationships.
When you first start one, it takes a lot of attention.
You have to be there,
and pay attention and work with it.
After its been going for a long time,
it builds up a sort of momentum of its own.
You still have to give it some care now and then,
but you can turn your attention to other things
and know that it is still there for you.
And yes, there's the wood getting and kindling gathering…
but isn't this a nice change,
a reason to be out in nature and fresh air?
I've come to treasure time with fire.
For like the very best of friends,
fire seems to be able to melt away
my tensions and frustrations, just by it's presence,
And so I am grateful,
to sit this winter evening
with my good friend, fire.

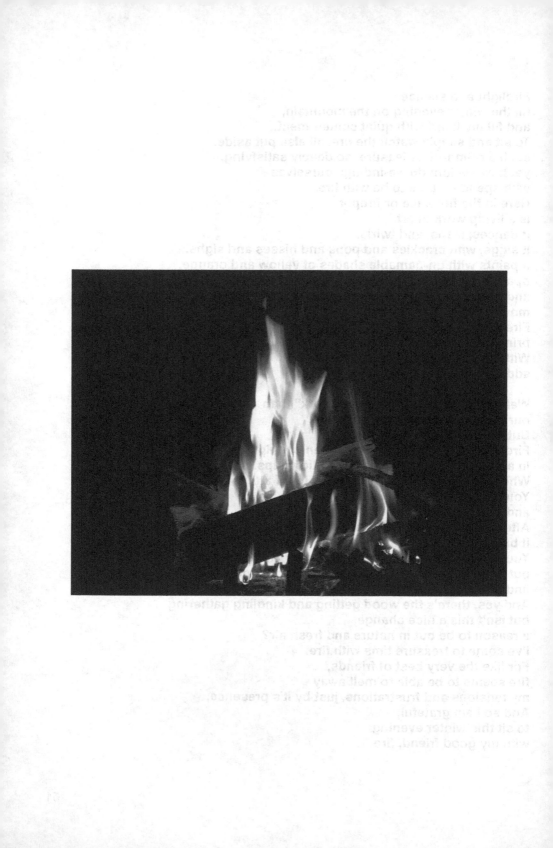

Warmth at my Hearth

Fragrant Cedar Smoke
Golden Flame
Orange Embers
Warmth at my Hearth
Rain pounds on the roof
Wind dances in treetops
In the cabin I am warm, safe, dry, cozy.
Mmmmm......
Outside the temperature falls
I feel it even as I walk past a window
Quilts piled on the bed await my slumber
Warm shawl around my shoulders
A cup of hot cocoa
The intensity of the storm is growing
Isn't life amazingly wonderful?
I sit quietly and ponder this gift from the trees
Heat and light and dancing beauty,
leaping out from these pieces of wood.
The last precious gift
of this once-was-a-tree
before it departs,
rising up in smoke
to the world of Mystery.
I am so blessed.

Sitting with Fire

Fire seems to have this inherent ability
to take us to a meditative state of mind.
Oh yes, it starts with wild activity,
flaring and dancing and crackling away,
perhaps because we too
are still in that place of busy mental activity.
But as we sit before the fire,
we slowly come to settle down and sink within,
as the fire sinks deep into the wood
becoming orange embers.

I breathe awhile,
and watch the fire.
I breathe awhile,
and stir the fire.
I breathe awhile,
and add another piece of wood.
I breathe awhile,
and give thanks for the fire.
And then again,
I breathe awhile,
and watch the fire,
and fire has succeeded,
in bringing me to quietness.

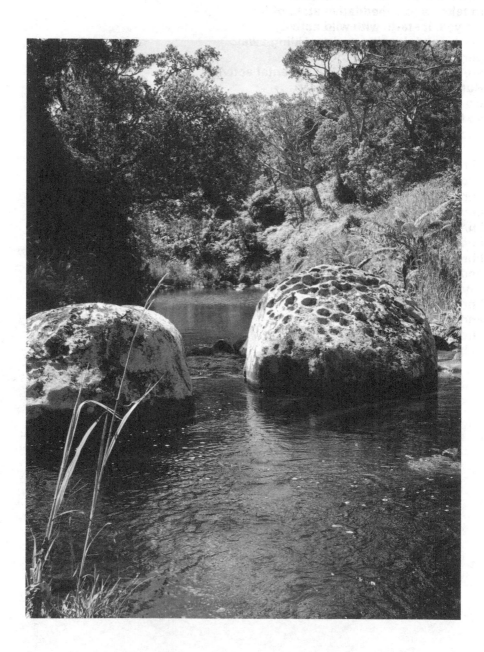

Stone holds the Dream

Stone...
Still, silent, strong.
We-who-rush hardly notice stone.
But stone is mountain.
Stone is soil-to-be.
Stone is the bedrock,
the very earth on which we dwell,
the ground beneath our feet.
And it is stone which holds the dream,
stone which anchors the energy of Place.

Great Spirit sang the song of Creation,
dancing from place to place
in wondrous creativity and endless variety,
an unprecedented exploration of expression.
And in each unique place,
each sacred creation,
the pattern of that place
was anchored in the stone.

The stone holds the dream.
The stone keeps safe the pattern.
The stone sings the song,
renewing the life, the being-ness of that place,
so that each particular precious vision
may continue to be re-created.

Many voices come and go,
tree people, bird beings,
a chorus of insects and flower song.
But the deepest note,
the grounding, the foundation,
is held by the stone...
the stone of mountain there before me,
the boulder on which I sit,
the ground beneath my feet,
the pebble in my hand.

When we-who-rush
are tempted to dismiss
this seemingly silent and unmoving stone
as insignificant,
as 'just a stone,'
perhaps we would do well
to slow down and listen
to what the stone is singing.
It is stone, after all, that holds the dream
of this, and every,
sacred place.

Earth

The mountains rise before me,
tall, strong, still,
deep, sure, patient,
knowing.
My eyes follow their shapes,
down from the highest peaks,
along ridges, into valleys,
into sculpted cliffs or soft molded hills,
with curves and swirls,
with mounds and depressions,
all clothed sensuously
in form-fitting soft greens.
No wonder Father Sky has
fallen in love with you, Mother Earth.

I love to feel my bare feet
on smooth, cool stone,
or on scrunchy hot sand.
Sometimes I feel the squish of mud,
when you call the rain
to come and play with you, Earth.
You give us land to Be on.
You nourish and support all the life
which then feeds us in turn.
You hold us in your hands, Earth.
And you give us surprises,
bits of beauty and wonder,
in the form of a gem or a crystal,
or an especially smooth stone.

Earth Mother,
I feel you when I nestle into my home.
Perhaps not a cave or a burrow,
literally holding your form,
but yet an essence of your "earthiness,"
there in my place of shelter, comfort and rest.

I hear you, Earth, in Cricket song.
Being nestled so close to you,
surely the crickets hear your song,
and then send it out to be heard aloud,
translated for our ears.
I know that when I hear them sing,
I also feel you rocking me to sleep,
Mother Earth.

And when I feel your Presence close,
then I feel stillness, and quiet, and strength.
Then I feel grounded, connected, and centered.
Then I feel I am here and now,
and yet with one foot in eternity.
When I let my awareness
turn to your Presence, Mother Earth,
then I know that I am at Home.

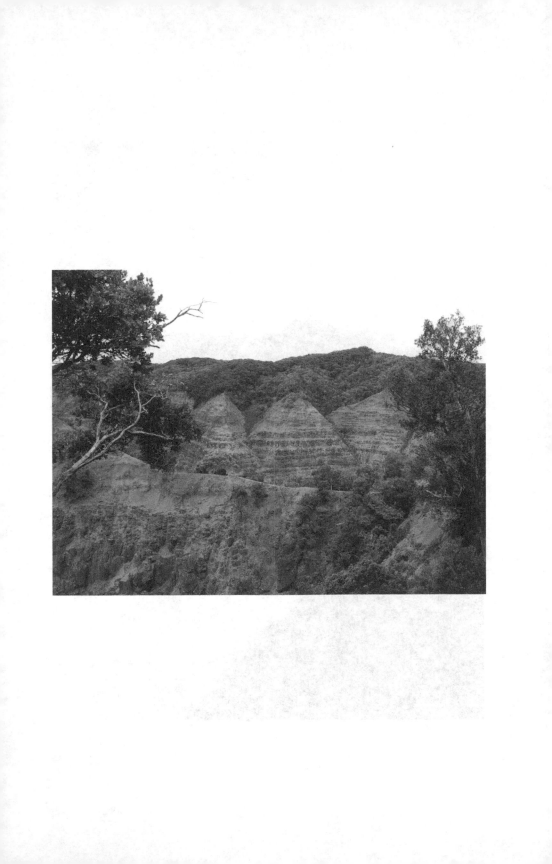

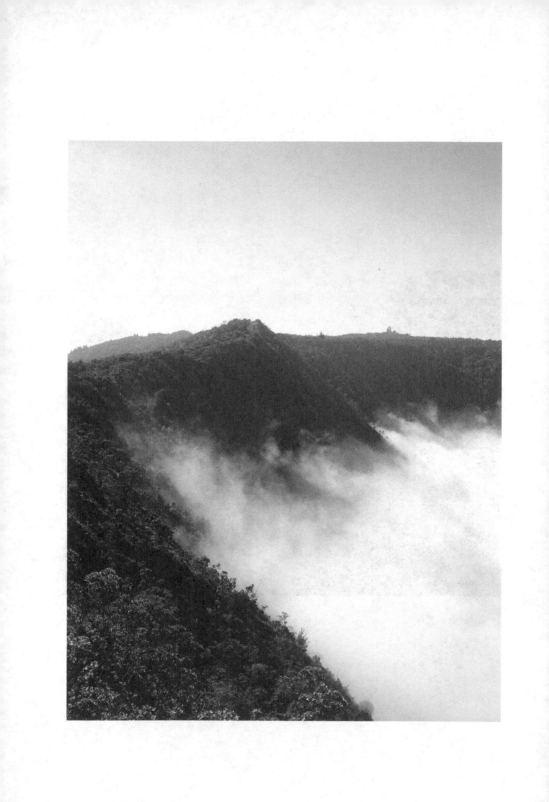

A Visit from Cloud

How magical, how truly amazing
to awaken one morning and find yourself
inside a cloud.
High in the mountains, cozy cabin in the woods,
I stood just the evening before on the small porch
and watched the last light of sunset fade away.
The many trees around me sang in the wind
and the brightly colored flowers here and there
settled into the darkness to rest.

I sat awhile before a golden fire,
then I too nestled down into darkness.
I fell asleep looking at brilliant stars
peeking in through the window.
My first awareness of morning
was the fragrance of ginger blossoms,
releasing their scent to greet the dawn.
I opened my eyes to look out the wide window,
and everything was soft fluffy whiteness.
I and the cozy cabin were in the middle of a cloud.
Silence. Stillness.
Only the vaguest shades of grey here and there
hinted that there still might be a world around me.

Slowly, a light breeze awoke,
and began to move the cloud into swirls and streams.
Then cloud too awoke, with a dreamy sigh,
and seemed to say, "Oh well, time to get going."
In an instant she was gone,
leaving only higher level grey sky above.
The world around me was here again,
tall green trees, a multitude of textures and shapes,
and here and there a bright color
among the soft greens and browns.

There's something about a day like this
that makes me content to just sit here,
to watch, to listen,
to breathe in the freshness of the air,
and to absorb that magical softness
that was left behind
by a cloud.

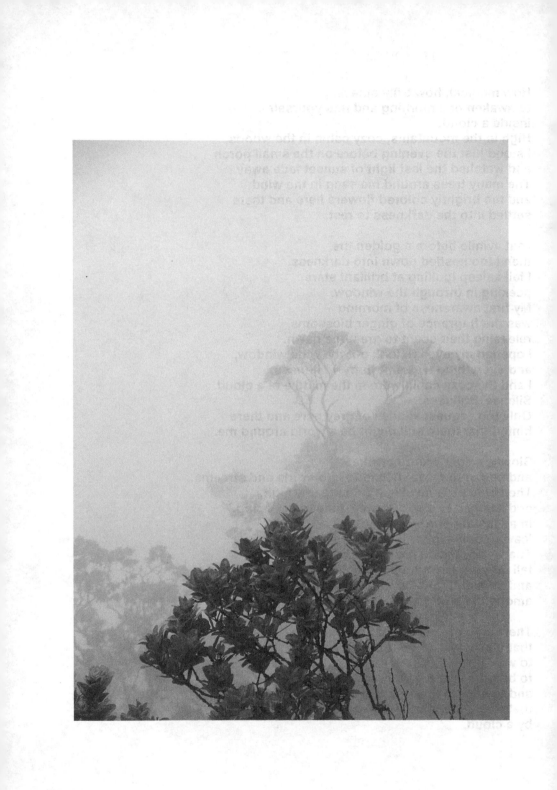

Heavenly Mist

Light and delicate, you fill the air,
gently falling from the heavens.
It seems you change direction at whim,
and are even unaffected by gravity's pull.

Noelani, you are a mist so gentle,
I hardly feel your touch on bare skin.
Yet before long
my hair shimmers with your dampness

Unlike most rain,
you seem able to coexist with sunshine,
filling the air with sparkles
like a tropical snowfall.

Tiny droplets cling to a spiders web,
transforming it into a jeweled work of art.
And then you are gone,
off to dance in swirls of mystery between the mountain peaks.

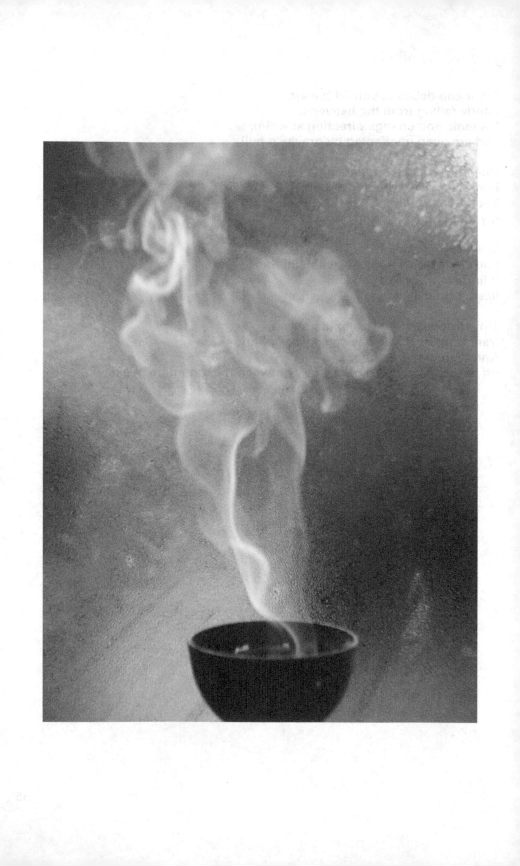

White Smoke Spirals

White smoke rises in the air,
incense seen against the morning light,
tall streams and ribbons,
swirls and spirals,
tube shapes and wide fans,
every moment changing
both form and direction.

Smoke knows better than to try to be static.
It carries the message
that flowing change brings beauty.
When mankind attempts to make things too rigid,
fixed and unmoving,
controlled and overly ordered,
it simply doesn't work.

The key seems to be
to walk the balance line
between chaos and control,
for in their right proportions,
they create a harmonious flow.
Too much of either,
leads only to frustration.

As the white smoke rises,
it is the seemingly impossible twist
that brings beauty…
In music, the unexpected chord,
or the turn of a melody in a new direction…
In nature, the flower that blooms
unpredicted, unplanned, unplanned…
In relationships, the spontaneous act of friendship
or assistance given unasked.

Humans need a sense of order,
else we could not accomplish
what we need to support our lives.
Yet Wonder and Beauty cannot be regimented.
Can we as humans walk a flowing path
that allows these also into our lives?
Can we move and change and live as gracefully
as white smoke spirals
rising gently into the air?

In the Company of Trees

In the company of Trees
I am different somehow,
not the same as I am
when engrossed in the world of humankind.
Perhaps it is that
in the company of Trees,
I see with a different perspective.
I see a different part of myself emerge;
a deeper part,
a more connected part,
a part that feels in some way more real.

In the company of Trees
I seem to be encouraged
to look at the Bigger Picture,
the long range view.
Trees, after all, do not do things in a hurry,
or make hasty decisions.
Trees have a way of reminding me
that patience is, after all, a virtue,
even if, regretfully,
found too seldom in humans.
There *are* certain things, they say,
that just Take Time,
(like growing a Redwood Tree,
or healing your emotions,
or becoming wise.)
On the other hand, there are things that take
being in a state of No-Time,
being in the stillness, in timelessness,
in a moment of wonder.
Trees are masters at this.

In the company of Trees
I have access to a wisdom
different from our own.
Trees understand better than we do
the importance of relationships
with others not of their own kind.

Birds, bugs, bees, breezes, and the warm touch of sun
all play their vital role in a tree's life,
their participation welcomed.

In the company of Trees,
I am lifted into Sacred Time.
Trees remember what it is
that is most important.
I am given a glimpse
into the spirit of Oneness;
the knowing that one is a part
of that which is All.
Trees show me how to open the door,
how to step out of my own busy mind,
to where I can feel the presence
of the life all around me.
And Trees understand how to move with time.
They remind me,
that if I just stop moving so frantically,
time will slow down for me.
It is only then,
that I can make the deeper connections
that fill me with wonder.

In the company of Trees
I again become aware
of the many, many gifts that they generously share,
with we who dwell in human form.
Fruits and nuts in variety and abundance,
materials to build and weave,
and fashion things of beauty.
And when their living days have passed
they hold yet still a precious gift,
in fire's light and heat and fragrance.
How many many patient days
did this Tree gather up the sunlight,
storing it inside the wood,
that now the fire releases for my use.

In the company of Trees
I am filled with delight,
I experience a hint of ecstasy.
And from the company of Trees
I return with that most precious gift...
a Peacefulness of Mind.

Bamboo Forest

Smooth, cool, green-ness
rises straight and tall
from earth to sky,
again and again and again and again.
Delicate leafy fingers
are lifted to dance and sing in the breezes.
The bamboo thicket surrounds me,
shelters me from passing rain,
embraces me gently,
and brings a gift of serenity.
How could I want
to be anywhere but here?

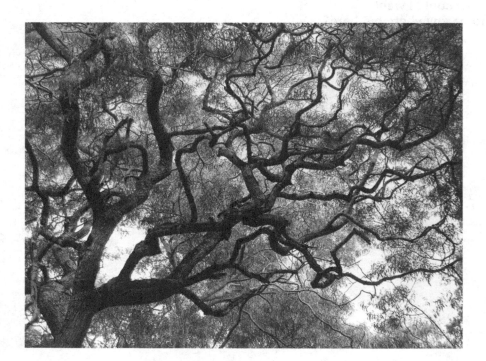

Being Tree

I have just sat down near you,
and already I feel the soothing of your presence, Koa Tree.

Standing there against the sky,
the most delicate of greens, almost silvery,
your crescent leaves cluster in feminine curls,
all around your head,
and drape gracefully from your outstretched branches.

"I feel your tension and anxiety," you whisper,
"Let it go. Sigh softly in the wind and release it.
Come to rest in the beauty of your Beingness,
Trust in the Flow of Life."

I look up at the tree.
You do, don't you, I quietly realize.
You sink your roots into the nurturing earth,
trusting it to bring you the nutrients you need.
You raise your branches to the sky,
trusting that the sun will shine upon them
to bring you needed energy,
Your leaves sing a song into the wind
sending messages to the rain,
and you trust that it will come to bathe you
and quench your thirst.
This is perhaps what I need to learn from you,
to take the needed action,
gently, easily, naturally,
and trust that the desired response will come.
You send out the roots, you lift up the leaves,
you trust, you receive.

There's something about Time too, isn't there, Koa Tree?
About being able to be so fully in the present moment,
because you trust in the combination
of your genes and your Spirit
to lead you, moment by moment,
into your ideal expression of Koa Tree-ness.

I appreciate you, Koa,
your beauty to brighten the morning,
your shade on a midsummer mid-day,
the air you freshen for my use,
your nurturing of the birds, who sing to me so joyously.
And, most of all,
that ethereal, un-definable energy of healing
which you so generously share with me.
The Great Mystery dwells, though elsewhere as well,
most certainly in you, Koa Tree.

Sleeping with Cedar Trees

I have felt in need of some comfort these days,
and so I have come to the trees.
Tonight I will sleep nestled among cedar trees,
dozens and dozens of them,
tall and stately,
all around my small dome tent.
Will you speak to me tonight, cedar?

Already the stream is singing to me,
along with a few twilight birds.
All day I have walked through air
thick with the nectar of ginger flowers.
And now the woodsmoke of my campfire
takes me even further
into the presence of this place
and a pleasant drowsiness.

Yet again I try to understand
the elusive magic that I find here.
Is it the total break from the routine?...
The solitude of a whole day
without having to speak?...
The energies of these nature beings
who are all around me?...
The drifting sunset clouds
and the half moon overhead?
There is a peacefulness here
that sinks deep to my core.

That so few come to spend time this way
amazes and distresses me.
How can they go on,
without this deep, healing, cleansing, restoring
embrace of nature?
How can they know their essence,
without sometimes sleeping with the earth
of which we are born?
How can they understand the cycles of life,
without sitting before a fire,
or watching the passage of the moon overhead,
or seeing a newborn flower open in the morning,
or hearing that the river flows
on and on and on all night long?

How can our society survive,
if we do not acknowledge
this basic nurturance of life?
And might it not be,
that if we learned to partake of these gifts
of wild nature's presence,
that we would have little time,
and even less inclination,
for anger, violence, and war?

The trees exude peacefulness.
Do you not want to let this seep into you?
The river dances gentle movement.
Just listening can free up the places you feel stuck.
The tall trees have skills as yet far beyond us.
They make their food and attire,
merely by standing in the sunlight,
and drinking in rain with some dissolved minerals.
Surely we have things to learn from them.

How is it that I myself come here so seldom,
for these wondrous nights in nature's embrace?
My life, like most these days,
is overly full with all of the things it seems to take
to live in today's world.
And yet,
often have I thought,
as I sit here in this magical time with nature,
that deep down,
in the real essence of life,
the time spent in this way,
is the most important thing that I do.

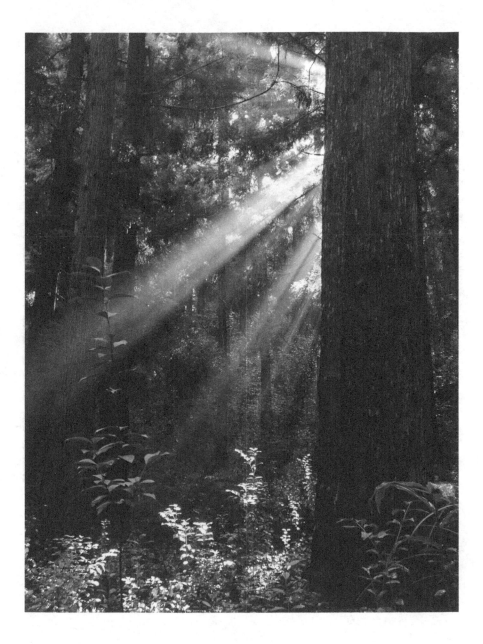

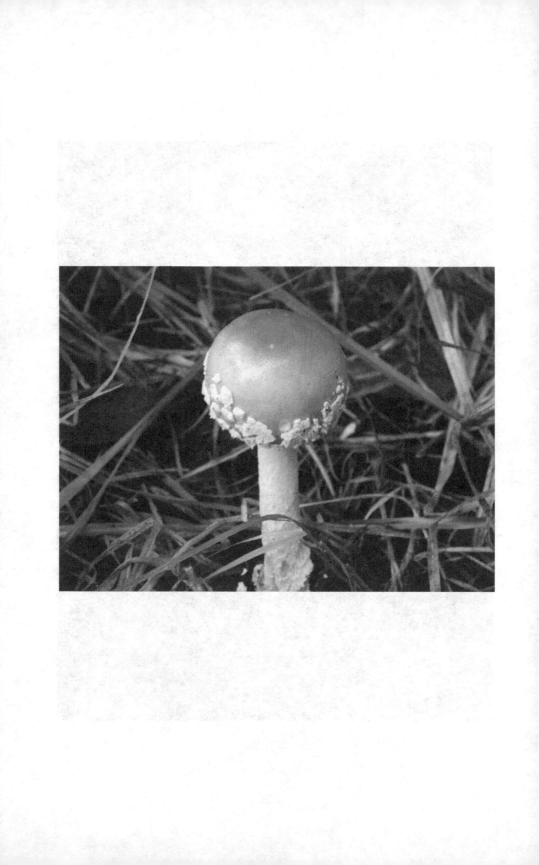

Lichen, Mushroom, Moss, and Magic

On these old logs,
no longer rooted in the earth,
and far past their days of being tree,
there live the most amazing things.
In rich shades of orange and red,
there are tiny platforms,
like fairy stair steps, or miniature balconies
along the side of the old, decaying log.
On another rise small slender towers,
in the most unearthly shade of green,
and on some are rubbery shapes
that stand out at the most unlikely angles.
Others have perfectly flat, extraordinarily thin layers
that look for all the world like a splotch of paint.
And there on the sides of a still standing tree trunk,
a velvety form-fitting coating of emerald green,
and a mound of climbing orange softness
so thick you can wiggle your fingers down into it.

Who are you?
Can you really be alive?
How magical you are,
to conjure yourself up
out of merely some old wood, some air,
some sunshine, and some rain.
From where do you draw these amazing colors?

I know your message to me,
yours and all your variety of cousins
who live in the woods nearby.
"Watch for miracles," you say,
"Look for the magic.
Anything is possible."

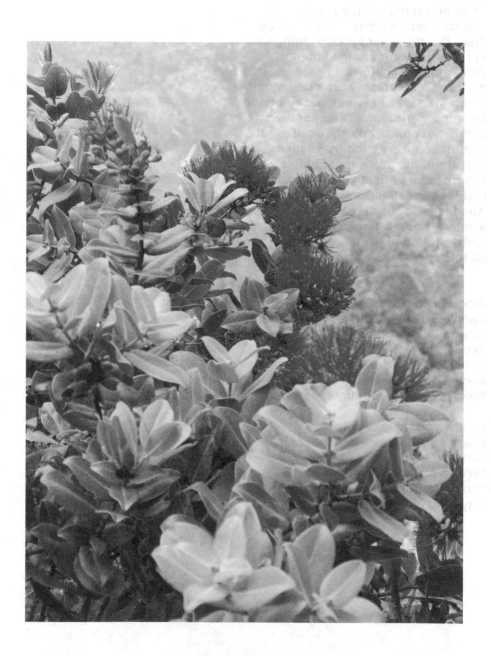

'Ohia Sisters

'Ōhi'a tree sisters,
how glad I am to walk in your grove
as you lift slender branches to the sky
singing the delight of the morning.
Your new leaves glisten in sunlight,
a deep dark red or coral-pink,
and some of you bear buds that are covered
in a downy white softness.
How lovely your dresses of patterned moss,
in so many shades and textures,
worn over your soft gray bark that somehow seems to stay damp
after all else around has already dried from the morning rain.
Already a few of you are dressed for summer,
wearing scarlet flowers with tips dipped in gold.
How elegantly beautiful you are.
The 'Apapane birds share my delight in your flowers
as they feast on nectar,
and perch in high branches to converse with each other.

It is here in the wildest and highest part of the mountain
that you most often choose your home,
and I sense that you have dwelt here for a very long time.
You seem equally at home in the mountain's gentle sunlight
or in the soft swirling mists.
Standing gracefully, smiling in stillness,
you are calm, and at peace.
Walking among you urges me to be so as well.

'Ōhi'a tree sisters, you seem always to have a gift for me,
the gifts of your beauty and your company,
sometimes flowers for my hair,
and from those of you who are the oldest,
some long dead branches for my evening fire.
And yet another gift comes to me as I sit here with you,
a message, silently spoken into my mind,
sharing with me the wisdom you have gathered
in the long years that you have lived here:
"The way to make everything all right
is to remember to Know that All is Well,
and to trust in the guidance given to you."

Dear 'Ōhi'a Sisters,
how wonderful it is to walk here among you,
in the sunshine and the mist of the mountain.

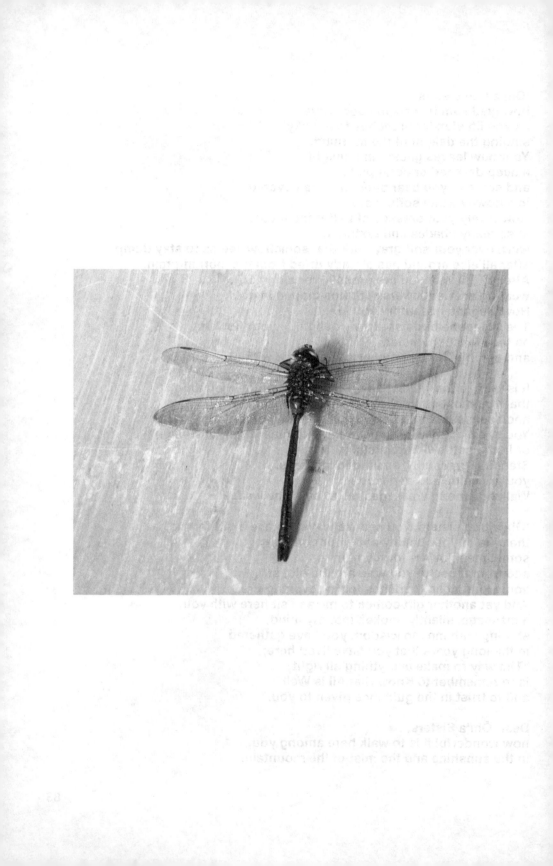

Dragonfly

Translucent wings, finely veined,
iridescent and shimmering,
their distinctive shape outlined against clear blue sky,
and then a blur of motion that tells me you are near, Pinao.
Your body glows with blue or green or red
as your quick movement teases my eyes
into trying to follow your flight.
Usually you are too fast for me,
except on those most fortunate days
when you honor my presence
by circling round and round me,
or even hover just above
and silently speak a message into my mind.

Dragonfly, how come you by your name?
Was it mythical mystical dragons
who were your ancient forebears?
You are the omen of mystery and wonder,
the bringers of good fortune and good news.
Everyone I know acknowledges your role,
though we all stand in awe of how this can be.

Pinao, you seem made of light and movement,
a breath of air,
a touch of water at your birth,
and hardly enough earth to keep you in this physical world
long enough for us to see you.
Is that why you seem to appear out of nowhere?
Do you just pop in from another reality?
And most certainly are your messages magical,
for they touch my heart with an instant knowing
wrapped in delight.
You come at no man's bidding,
but appear when it suits your own purposes,
and welcome indeed you are.

Dragonfly, how blessed am I
by your delicate, wonderous presence.

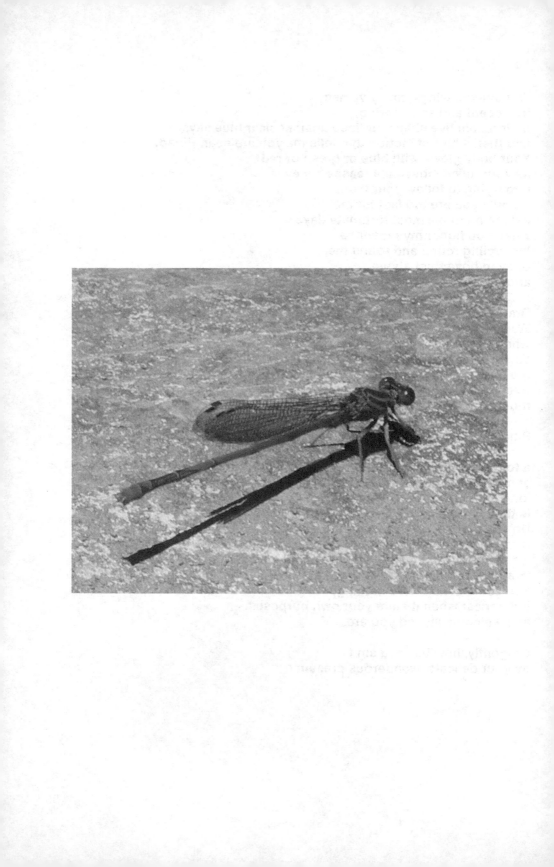

Damselfly

So delicate, dainty,
flitting above the small stream on Pihea trail,
I'd seen you in this place before,
and once again paused to marvel at you.
You perched on a boulder in the stream
and sat very still.
A brief flutter around and back to the same spot,
directly in front of me.
Once before, here in this same place,
you'd come to me, and sat on my finger.
Or was that your mother, or your grandmother?

Now you sat again, at a slightly different angle,
very, very still.
I seemed to hear the thought
placed by you in my mind,
"Well, you would like a picture, wouldn't you?
Get out your camera."
So I took off my pack, got out my camera,
and sat down on a boulder.

The time we spent together then
was most amazing, little damselfly.
I have no doubt that you were posing for me,
as you sat first at this angle, then at another,
as I tried various camera settings.
You chose one background, then another,
stone, log, leaf,
and each time sat still a very long time,
allowing me even to come within
a few inches of where you sat.

I wondered at your fearlessness,
but you showed me how quickly you could depart,
so fast that I could not see
in which direction you had gone.
I think you were laughing at my thought
when you returned to pose again.
That I am several thousand times larger than you
did not seem to concern you at all.

I had tried on other occasions
to photograph your larger cousins,
the blue dragonflies.
They had me spinning in circles,
my photos nothing more than a blur.
How gracious of you, damselfly,
to give me this opportunity,
and for giving me this reminder.
For we humans can be
so arrogantly foolish sometimes,
thinking we are the only ones
with wisdom and with love.
This day you have showed me yours,
little red damselfly,
and I am grateful.

Pueo

Little Owl, Silent, Elusive,
Even the smallest glimpse of you
is filled with Mana.
You ride the between times,
between night and day,
between this world and the spirit world,
and carry silent messages
that ring crystal clear
when you place them in my mind.
When I see you,
you make sure to let me know
that this is no mere chance occurrence.
You change your course
to keep pace alongside me,
or swoop down to cross
directly in front of me,
like a wise uncle who looks at you,
raises an eyebrow,
and merely says, "Well?"
Mostly what you tell me
is something that deep down I know,
and have promised myself to remember.
You catch me at that moment,
when I am almost about to forget.
And so, gently, you nudge me back
onto my path.
Thank you, Pueo.

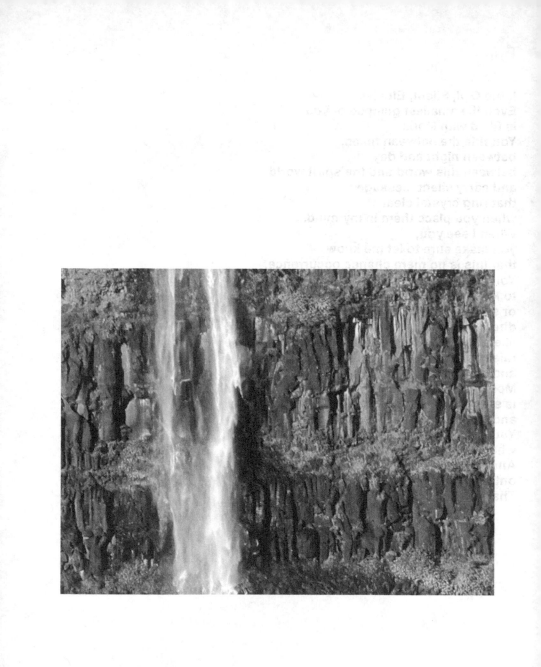

The Elemental Dragons

Elemental Powers swirl and flow
all about the planet,
around, within, and throughout all,
restoring, renewing, invigorating, transforming
all that dwells upon this Earth,
all that Is this Earth.
Known of old as Elemental Dragons,
they hold amazing power
and wonderous magic.
Many are the forms that they create
to express themselves in this world,
ever moving, ever changing,
and Being our planet.

Elemental Earth

Here in huge boulders,
heavy beyond imagining,
yet once the Earth Dragon moved them,
in volcanic eruption or a torrent of flood,
with the help of her co-dragons,
to place them here.
Earth expresses also
as tiny smooth pebbles,
and sparkling precious gems.
Earth is stone ground down to sand,
fine and soft and shapeable.
Earth is the wonder of soil,
filled with microscopic life,
holding and feeding the world of plants
from tiny sprout to towering Redwood,
as well as cave and burrow
that shelter the animals.

Earth energy brings a place to rest,
to be held safe,
to be still, secure, serene, strong,
a time to be here, in this moment.

Elemental Water

Perhaps the master of shape-changing,
she is the most delicate of mists
gently riding the mountain breeze,
and the pounding tropical downpour.
She is the still pond reflecting moonlight,
and the flowing stream,
forming ripples, currents, cascades,
and a plunging waterfall.
She is the vast and deep
and exceedingly powerful sea.
She laughs and sings in a thousand voices
and wears many colors,
depending on the mood of sky and sun,
and sometimes, it seems, just her own whim.
She may appear black or brown, red or grey, blue or green,
shimmering turquoise, frothy white, or crystal clear.
Known as the primary liquid of life,
she will ride a change of temperature
into solid ice or vaporous gas,
though she carries milder versions of heat or cold
to soothe or invigorate us.

The Water Dragon flows in a multitude of paths,
ever changing, shifting, this way or that,
in the river water's quest to reach the sea,
and the sea water's urge to touch the shore.
Back and forth she moves,
between Father Sky and Mother Earth,
carrying their love to each other,
riding the cycles of evaporation and rain,
absorption and discharge,
around and around,
again and again.

Water energy can move around obstacles,
release what is not needed,
hold endless possibilities,
and move with fluidity and timeless endurance.

Elemental Fire

Heat and light radiate from our Sun,
the energy pouring forth
to sustain all life on Earth.
The magic of fire blazes forth here,
in earthly forms as well,
so we know hearth fires, and campfires,
candlelight, and furnaces,
and even the metabolism with in our cells.
Yet to watch a burning log
with a red glow inside it,
and suddenly there are dancing flames,
yellow, orange, sometimes even blue,
and then they are gone,
and then they return again,
do you not have to wonder of fire,
what, really, is it?

The Fire Dragon is active, passionate,
quick to come or depart in an instant.
On a sudden whim,
he may send forth a lightening bolt.
In a gentle mood his warmth can nurture,
bring us comfort,
and nourish with the alchemy of cooked food.
Fire may dwell deep within the earth,
melting stone, building pressure,
ready to re-arrange a part of Earth's crust.
When he chooses to express with force,
his actions may be violent and drastic.

Fire energy brings light, and heat,
passion and vitality,
and sometimes total transformation.

Elemental Air

We sense it as coming and going,
a breeze that touches us and moves on.
But it is always here, always everywhere,
in every space between everything else.
Air is the great transporter.
To me it brings Oxygen, and warmth or coolness,
a multitude of fragrances,
a vast array of sounds.
To each living creature,
it carries what is needed,
and even gives the medium through which
the flying ones move.

The Air Dragon loves to play with his siblings,
stirring up fire into flame,
rippling the surface of water,
even sometimes moving some earth.
His moods vary greatly,
sometimes sitting almost perfectly still,
yet when there's work to do,
can muster the force of a hurricame.

Air energy holds movement and lightness,
thought and inspiration.

These Elemental Powers
together act in harmony
to maintain all of the life that we know.
From the Sacred One Stillness they flow forth,
and to the world of Nature they give their gifts.
How blessed we are for these wonderous beings
of Earth and Water, Fire and Air.

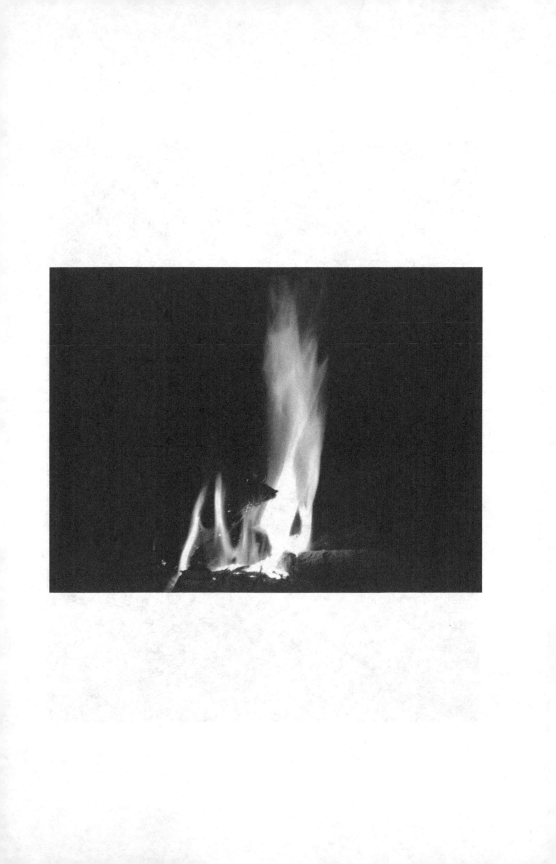

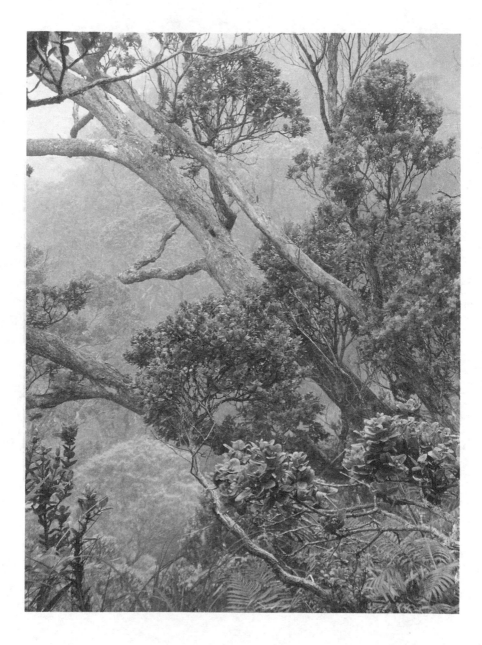

Magical Places

Many people like to make collections of things; coins, dolls, stamps, antiques, etc. My own favorite collection is Magical Places. These are places in Nature that I have found where there is an exceptional feeling: an energy, an exquisite beauty, and a strong sense of Nature's Presence being very much alive and conscious. These are places where it is easy to sink into a sense of the Oneness within all life.

Magical Places most often are places where Nature is free to do her own thing. A park that is overly controlled by humans, being mowed, weeded, pruned, sprayed, planned, and transplanted, while it may meet the needs of some people for their outdoor activities, simply does not give Nature the leeway she needs to create her true magic. Wilderness is Nature's creative laboratory.

Each time I would visit one of my favorite places, I would be filled with a sense of amazement. There would be new things I had never seen before, artistic groupings and arrangements, examples of different life forms helping each other, moments of perfect timing to give me an unusual or incredibly beautiful sight, and patterns and colors of infinite variety. But as if this wasn't enough to keep me totally in awe of Nature, I began to experience moments that were even more magical. Really magical, as in beyond the explanation of our current scientific understanding. It seemed that Nature was introducing me to the idea that Reality includes far more than we think and that more things are possible than we could imagine. I began to be open to the omens and messages that Nature had for me, and the wonder continued to grow.

On the island of Kauai there is a mountain on which there are two side by side state parks, Kōke'e and Waimea Canyon, and it is here that the experiences occurred which led to the writing of this book. While I hope you will be able to spend some time in this wonderfully magical place, it is also true that there are other magical places. In fact, the world is full of them, scattered here and there like hidden jewels. Go out and seek them. Close your eyes and ask the Earth to lead you to a special Nature place, and then listen to what your intuition tells you. And when you go to find them, remember: you must be looking with your heart as well as with your eyes in order to see them.

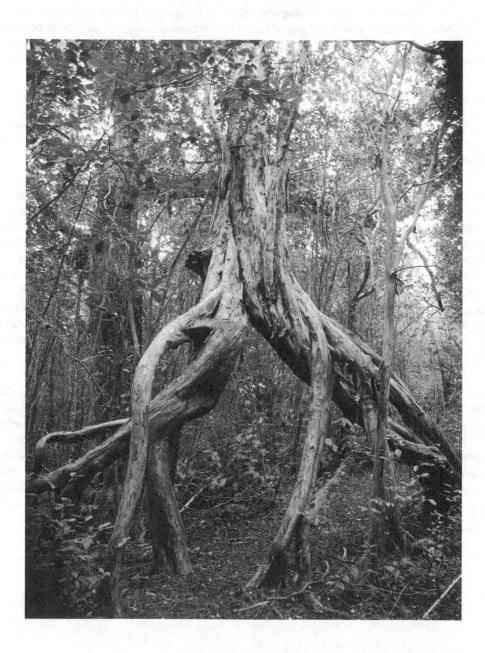

The Enchanted Forest

Sunlight and Shadow
woven together like delicate lace,
green ferns and tall trees,
climbing vines and hanging flowers,
and the hidden homes of fairy folk;
the enchanting forest welcomes you.
Slow down,
and soften your gaze,
and you just might see
the golden-green glow
in the hollow of a tree
that hints at the presence of the nature spirits.
This is not a place for your mind,
for facts and figures and serious conversation.
It is place for your heart.
Drink a dewdrop
from a soft moss
sparkling with the touch of sunlight,
and feel the essence of wonder.
Listen to cricket song
in the cool shady forest,
even in the middle of the day.
Feel the sun's warmth
in a field bright with flowers,
where the birds sing their delight
at the feast of ginger seeds.
Stand under a majestic archway
made of the roots of a living ʻŌhiʻa tree
perched above the trail,
and know that Magic is,
indeed,
alive.

May Day in the Forest

Lying on the forest floor amid dry leaf litter,
my head is pillowed by a moss covered log.
I feel the sunlight on my face,
along my body,
and notice how it seems to be melting me,
melting the boundaries, that is,
that keep me locked inside, and separate.

The sounds around me draw me out, slowly, gently.
There is wind in the treetops high above,
and a gentle rhythm of crickets in the distance.
Closer, a bird calls to my left,
another answers from the right,
and a twitter of small birds from higher overhead.
Fragrance rises to envelop me,
moss and leaves and maile vine.
I let my awareness drift further out,
outside of my limiting body,
as if I am caressing moss covered tree trunks,
or sitting on a high branch that sways in the breeze,
or riding a fast moving cloud high above.

As I leave the woods I notice, that now,
even though focused back inside my normal form,
I feel I am someone else.....
different somehow, renewed and refreshed
and it feels.....so.....good.

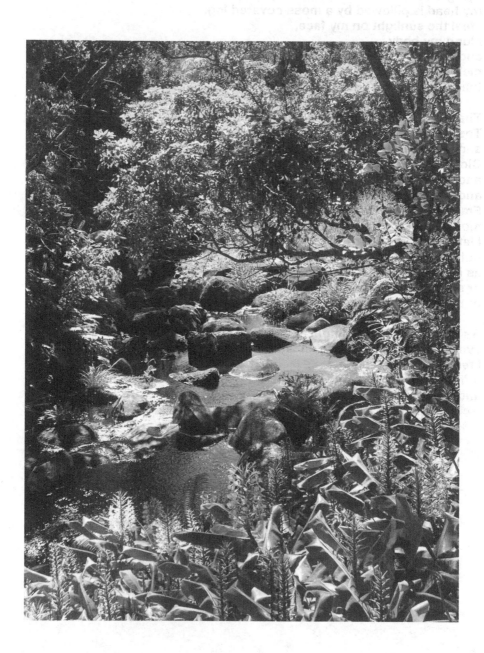

In Beauty I Wander

In Beauty I wander...
in places of nature's delight,
this day shared with me.
Gentle mist falling, silently, softly,
kissing my face and adorning my hair
with tiny droplets that turn into sparkles
in the next moment's shift into sunlight.

Tall trees stand on tiptoe,
dancing in the morning light.
A light breeze rustles one
into a spell of soft giggles.
Everywhere water trickles this day,
miniature waterfalls singing into small pools,
little streamlets for me to cross,
and squishy red-brown mud
that jumps up to play with me,
whether I invite it or not.
Even while part of my mind is sighing,
"Oh well, more wet dirty clothes,"
another part cannot help but smile,
"Now this is really becoming immersed in nature."

At the top of the ridge I stop to sit
and gaze into the long valley below.
Un-nameable greens and shapes and textures
weave enchanting patterns
that hold my vision for a long while.
She can sense it, I know.
If it's one of those times
that I need healing or renewing,
Nature whispers on the wind,
"Time for some serious Wonder Working."
She doesn't disappoint me.
For when I leave this viewpoint,
I step into a wonderland indeed.

Vines hang down with leaves that are somehow
both pink and green at once,
though I cannot tell where one color ends
and the other begins.
Everywhere I look there are mosses;
covering stones, climbing trees, carpeting the ground,
forming intricate arrangements perched on decaying logs.

There are mosses that lie flat and smooth,
others that stand tall, some that hang down from above,
some in mounds like little round cushions,
others resembling ferns of a size for fairies,
and some that look like puffs of green cotton candy.
They come in a multitude of colors; deepest dark green,
bright chartreuse, and every green in between,
as well as brown, yellow, orange, salmon, sage, and burgundy.

Mist and sun, mist and sun, the mosses love this weather.
I begin to notice the arrangement around me.
In this place it seems that Nature does not
just haphazardly toss things here and there.
Everything seems to be deliberately and artistically placed,
to create a scene of beauty.
A dark hollow in a tree, moss edging around the opening,
a fern placed beside the entrance,
a little alcove to one side also decorated with moss...
Have I stepped into the homeland of the fairies?
Perhaps it is they who create these amazing arrangements.
A golden sparkle catches my eye...
perhaps a raindrop perched on moss,
but it seems to shine even after the sun goes behind a cloud.
And in the instant mist that suddenly fills the air,
something, or someone, seems to whisper to me,
"Remember the Magic."

A single bird sings a hauntingly sweet song.
The fragrance of wild honeysuckle floats around me,
and a foot-long ginger flower
glows brilliant yellow in a burst of sunlight.
A red damselfly holds very still as I come close to see her,
then perches an instant on my extended hand,
and looks me in the eye, as if to say,
"Well, you didn't want an ordinary day, did you?"

And I smile, and realize she has done it again.
Nature has turned my human-preoccupied turmoil
into the remembering that we do indeed live
in a most wonderous world.
And the same Life Force that cares for each tiny butterfly
will also, if I allow it, take care of me.
In beauty I wander, through this amazing life.
And as I do, may I too walk with beauty.

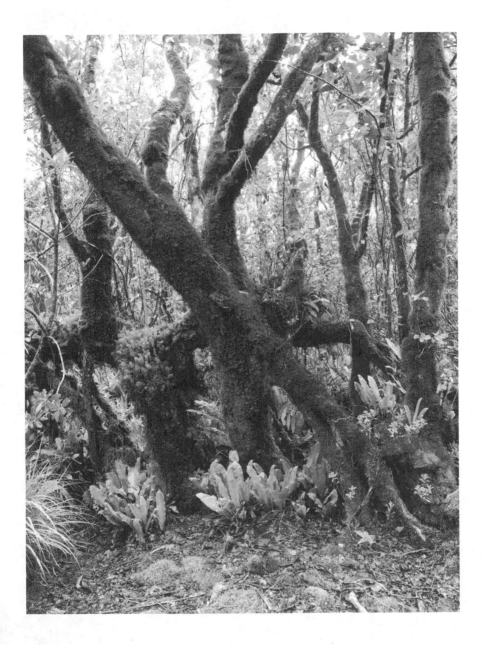

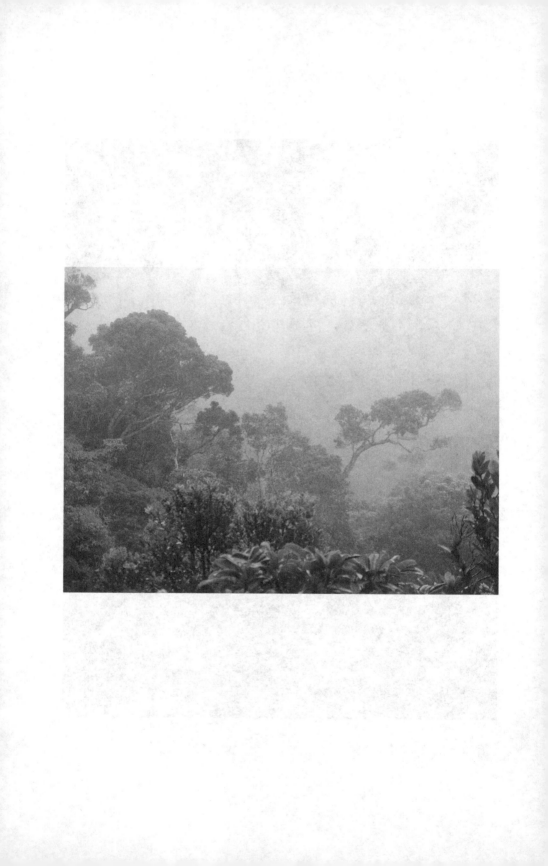

Sacred Place, Mystic Place

Sacred Place,
How precious this time
of being with you once again.
What is it about you
that so transforms me
each time I am here?
I breathe deeply,
and your fragrance tells me
that magic dwells in the very air.

I walk on a cool, wet, wintry day,
deep in old woods of redwood and cedar.
Stillness hangs in the air,
like a thick, soft blanket,
over which lies a lacy coverlet
woven of the songs of birds,
each crystal clear and beautifully defined.

Breathing the evergreen scented air,
I feel, rather than hear,
the peaceful reverence
of a deeply toned Ohm,
silently chanted by the trees around me.
I watch the tiniest of raindrops,
sparkling in golden sunlight as they gently fall.

Mystic Place,
How dare I tell of the wonders you show me,
lest I seem full of wild exaggeration?
Yesterday I walked the rim,
gazing deep into the valley below.
You greeted me there,
with the most brilliant of rainbows,
hanging in mid air,
set against the dark green of the distant cliffs.
Long did I stay to absorb this beauty,
and the rainbow stayed with me.

Then proceeding along the trail,
beauty upon beauty did I see,
a lushness of vibrant wonders,
as always I find here in this place.
Some several hours later,
I return along the path,
and again, in the same place,
the brilliant rainbow greets me.
Now my logical mind speaks out to protest,
"Hard enough to accept
a rainbow that hangs where there is no rain,
or cloud or even mist to be seen,
but now this...
the same rainbow here in this very same place
but four hours later?
The angles are all wrong!"
I laugh in reply,
"Don't ask me!
I won't pretend to know how, or know why.
If the rainbow can accept the magic
enough to be there,
then I am going to accept the magic
enough to enjoy it."

Sacred Place,
How is it you touch me so deeply?
Through the days I spend here,
time and again I go from cozy cabin,
out to walk in your wild places.
Within moments,
I am filled with ecstasy.
Whether dry or damp, cold or hot,
windy or still,
though I feel the changes,
they do not matter...
the magic touches me regardless.
When I am there,
there in that wild world of beauty,
some invisible boundary
seems to dissolve,
and the life within me
merges with the life around me.

108

And for a moment,
I AM that world;
I am the fern,
and the mosses,
and the swirling mist.
For that moment, at least,
the Oneness of Life
is not a theory,
but a knowing.
For that moment,
I see Spirit shining in a multitude of forms,
in radiant beauty.
For that moment,
I know that it is the same Spirit
that dwells in me.
For that moment,
I know ecstasy.

And then, just when I'd hoped
I could stay there forever,
my mind trips over some old habitual thought,
and breaks the connection.
Ah, well,
my life has yet other needs to be met,
and I must tend to them too.

But know this, Sacred Place,
even as I know it beyond a doubt myself:
I will come to you as often as I can,
for I bless your presence in my life.
And, Mystic Place,
may I ask you this:
If one of these days,
I bring someone with me, bring someone to meet you,

Will you show them the magic?
Will you show them the wonder?
Will you show them why I call you
A Sacred, Mystic Place?

For the Gentle Ones

There are some in this world
who are the Gentle Ones,
delicate, soft, small, unassuming,
these plants live their quiet lives peacefully.
Unfamiliar with the ways of war,
they carry no defenses.
Theirs is the ecstasy of living in this moment, this place,
in the wonder of being alive.

There are others who come who carry aggressive ways;
Plants with thorns and brambles and poisons,
or fast-growing towering forms
that crowd out the little ones,
or climb all over on top of them.
Animals with rooting snouts or tromping hooves,
that tear up the ground where the gentle ones live,
or dig up their young seedlings
before they even have a chance at life.
And humans too,
besides bringing in these aggressive others,
themselves have many ways that disturb these delicate ones.
As if that weren't bad enough,
we rationalize away our destructive actions,
saying, "Survival of the fittest," and all that.
Well, I believe that Darwin has been very misinterpreted.
For we generally seem to take "fittest"
as meaning the most aggressive and domineering.
But perhaps the better meaning of "fittest"
would be the most cooperative and adaptable.
For the true way of Nature,
when we let her systems stay intact,
is one of harmony, cooperation, and working together,
each with their task, and their own place in the picture.
And very special places, indeed,
for the gentle ones, the quiet ones.

As humans we are blessed with choice,
beyond mere instinctive action.
Perhaps we can choose to honor the gentle ones,
to carefully keep places safe for them,
the ferns and mosses, the maile and mokihana,
the lichen and the mushrooms,
to take care that we do not crowd out
those who have lived here so long before us,
the Koa and 'Ohi'a and the Sandalwood.

So much of the beauty of this world
is found in the living delight of the gentle ones,
the dragonflies, and butterflies, and small forest birds.
We do not want, surely,
a world where only the aggressive survive,
where the rule of the day
is to over-run others and claim their spaces?
Keep in your mind and your heart these gentle ones.
Help them be safe in this world,
and they will reward you well,
sharing with you their exquisite delight
in the joy of being alive.

Are there Sacred Places in Kōke'e?

They've been called the green cathedrals,
these forests of tall, stately trees,
and rightly so.
A few steps down the path and you feel it.
This is Sacred Space.
The stillness envelops you like a soft embrace.
Golden light filters through the leaves
sending slanting beams down to the forest floor.
And if you are quiet,
if you let your heart open,
you feel the Presence...
the Spirit of Life,
the Source,
the Creative Energy,
the Oneness,
that which is really beyond a word or a label.
You know in your mind, of course,
that it dwells everywhere.
But here,
here in these forests,
here on this mountain,
here it is so close to the surface
that you can feel it's presence.
Here you can come so close
that it can whisper into your heart.
It is such sacred places
that take us out of our normal mindset,
that turn off our human chatter.
The view that takes your breath away,
the wonder of an intricately formed insect,
the intense color of a flower,
the fragrance of deep woods after a rain,
the moonlight shining silver on a crescent leaved Koa,
the bird that sings just before the sun rises,
to welcome the new day.....
these are sacred places, sacred moments.
They stop us in our tracks,
and allow Spirit to touch us and say,
"I'm right here, you know."

Some people look for Sacred Sites as if seeking a street address.
"Is it this way, or a little more over there?"
They seem to assume that if
someone did not mark it, border it, define it,
a few hundred years ago at least,
that it does not exist, it is not there.

But it is all around this place,
among the trees, atop the ridges, tucked into deep valleys,
in moments that suddenly and unexpectedly appear.
How could a person possibly point out
merely one spot, and say, "It is here."

Those who have gone to the mountain
with intent to feel, to listen, to be guided,
can tell you it is real.
Sacred space is not a thing of some by-gone era.
It is as present now as before.
Perhaps it is just that fewer now go to experience it,
or are willing to acknowledge it.
But the need for it remains,
even stronger now,
since our day to day lives are so cluttered
with over stimulation, confusion, and false values.

We must preserve the essence
of these places that allow us such magical moments.
And we must allow them to be experienced,
as often and as deeply as possible.
To be touched by the oneness
can heal most things that disturb us.
To be for a while face to face with the Creative Spirit
can transform your life.
Come.
Come to the mountain,
and move slowly and quietly.
Come to the mountain with open heart, accepting mind.
Come and ask the mountain itself
to show you Sacred Places,
and then you will know,
beyond a doubt,
that they are here.

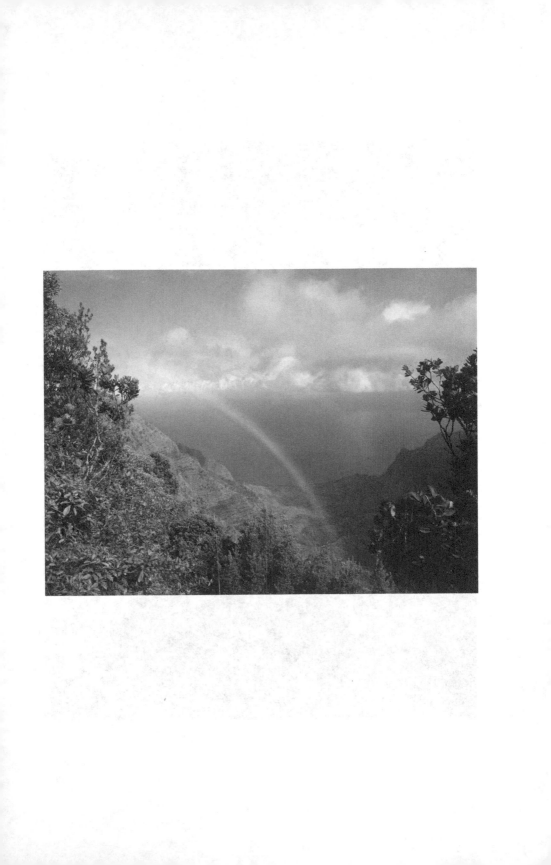

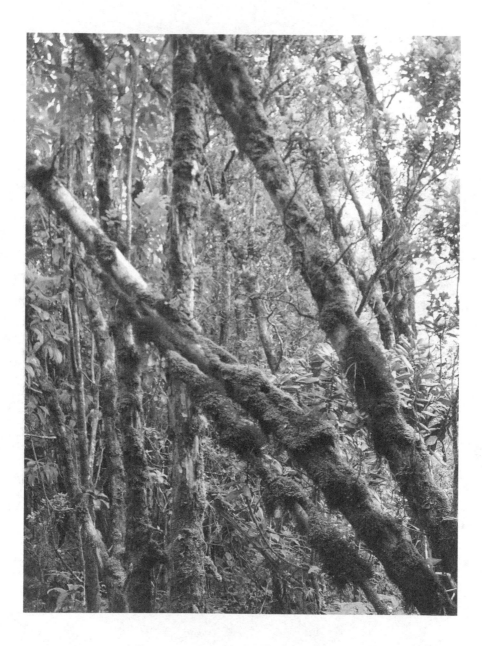

Magical Pihea

Whether from ancient times, or future ones,
I feel a connection calling to me,
a belonging in this wondrous place.
I play a song on my flute to Pihea,
and mist floats before me,
surrounded by sunshine.
For a moment it dances,
then disappears.

I enter the grove,
slender trunks of young 'Ōhi'a,
arms raised to the sky,
singing softly.
Looking with them toward the sky,
I see the sun between their branches.
Mist hangs in the treetops,
and the sun is circled
by multiple layers of rainbow.
From this center
the light streams out in rays
through the delicate mist.
It reminds me that I enter here a cathedral,
that this is indeed sacred space.

A tiny path between the trees
leads to a place for me to sit.
As I look around
I am filled with amazement
for this is truly a moss paradise.
On every trunk cluster colonies of mosses,
more varieties than I ever could imagine,
carpeting all around me in softness.
They invite me to sit with them.
Halfway up an 'Ōhi'a trunk,
a deep red moss reaches out horizontally,
catching a glint of sunlight
and glowing like a living fire.
As I look further
I see hues of rust and orange and brown,
and a multitude of shades of greens.
And the diversity of shapes...
well, I won't even begin to try to explain them.

Above me the melodies of birds
weave a strange mixture
of song-like notes and metallic taps,
with a gentle breeze whispering
the occasional harmony.
A dewdrop perched on a moss catches my eye
with a brilliant sparkle of sunlight.
Or perhaps I should say,
that for a moment I had mistaken for a dewdrop
what must be a tiny fairy,
for upon my notice it begins to glow brighter
than anything else around,
and changes colors from golden to green to red,
and around again.

As the wonder of this place seeps into me,
I ponder what I could possibly say
to describe to another the feeling of being here.
For a moment a cricket sings out,
mid-day though it is.
A tightly curled spiral
of a yet unopened frond of tree fern
looks at me, like the eye of the forest.
A silent voice speaks in reply to my silent question.
"In the forest, magic lives," it says.
"Just tell them that magic lives."
And as I step once more onto the path,
the voice of Pihea speaks softly,
"I will take you to the places where wonder dwells,
and beauty beyond your imagining."

Kalalau Ridge

The wind, Makani, was so still this morning
that only the Lapa-lapa trees were singing,
and then, only occasionally.
What you did hear were the birds,
and their songs seemed different today.
The air had an uncommon quality to it,
sound traveled through it more easily than usual.
Every sound was crystal clear and sparkly,
as if there were trails of shimmery silver light
carrying the sounds without resistance
through the still air.
A young tree fern lifted five new leaves,
carefully, to the sun.
A bird high up in an 'Ōhi'a tree
sang its blessings to the day,
and a chorus of bees hummed softly
in the background.

Walking the trail along the rim, I came to a halt.
Kalalau valley spread out before me,
lapped by a soft blue sea that rose to the horizon,
until it merged seamlessly with the sky.
Across from me rose the Pali,
cliffs that formed the distant wall of the valley
still somewhat dark in the morning's shadow.
Behind this sculpted dark green ridge
the sky was a brilliant blue.
Countless times have I stood here,
in this very sacred place,
gazing down into the valley,
gazing out to the distant sea,
gazing across to Kalalau's ridges,
and feeling that here, in this place,
I was at home.
Countless times have I been blessed
with joy, with peace, with wonder, and with beauty,
each given to me as I sat in this place.

I had come this day to walk in Sacred Space,
to step into the dreamtime in the mists of Pihea.
I had come to focus energy
to bring about what I desired to manifest.

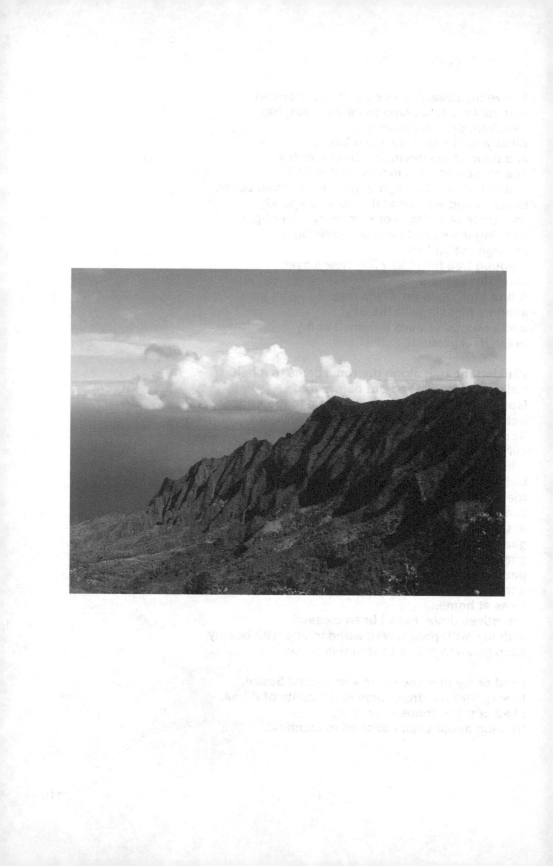

I greeted Kalalau and Pihea,
with simple flute melodies to carry my thoughts,
and simple statements to focus my intention.
Sitting in these uplands, I felt Spirit's presence,
and I spoke to claim what I would create.

As I looked to the ridge, one shape caught my eye,
with a point that rose straight toward the heavens.
The words appeared swiftly inside my mind,
"Visualize what it is that you would create.
Place the image here, on top of this point,
and energy will flow to carry your dream aloft to the heavens,
where it can begin to manifest into your reality."
I finally know not to question such things,
so I did what the ridge had suggested;
focused my thoughts on what I desired,
and mentally placed them in a ball of light,
on top of the point of the ridge.
In that moment, I saw the mountain's aura,
energy glowing all across the ridge,
like a bright, light blue flame that rose
from out of the dark green mountain.
And from the point that rose toward the sky,
the light flowed upward as a beam to the heavens.
There could be no doubt that here there was power,
and here there was mystery, and magic.
There could be no doubt that my dreams were being carried,
both by and to, a power greater than I.
And I knew then too, that I was not the first
to find the power of this special place.
Throughout the ages Kalalau has been known
to work mysteries and magic,
with powers that lay beyond our comprehension.
What was mine now to do was to focus and ask.

I turned at last to walk the trail into Pihea's wilderness.
Here surrounded by lush green softness,
it seemed that the spirit of this place spoke.
"Open the connection," she whispered.
"Its about remembering to complete the circuit.
When you open the pathway from a human heart,
to a being of Nature, to the One Great Spirit,
then the circuit is complete.
Then all manner of wondrous things
are indeed possible, are indeed probable,
are indeed, brought into reality."

Once more along the trail,
the trees gave way to another clear space
giving view to the valley below.
I looked across to the same point on the ridge,
and a new image flashed before me.
It seemed part of the cliff had now transformed
into a giant 'Iwa bird, seen from above.
The tall point was her beak, where she carried our dreams,
as she took off to soar up into the sky.
And again I knew all that I needed to do
was to hold my vision, and to trust.

Mahalo Kalalau, Mahalo Pihea.
Thank you for reminding me,
why it is that I am called here
yet again, and again,
to Kalalau Ridge.

Here, in the mountains,
everything seems different somehow.
I walk out to greet the wildness,
and things begin to happen deep within me.

Here, in the mountains,
there's something different about the air,
besides the mist from a passing cloud,
besides the fragrance of blooming flowers.
There seems to be a freshness here,
a spaciousness of light and sound
that lets me hear the treetops murmur,
and the gentlest songs of birds.
It lets the sunlight reach
into my inner self and make me smile.

Here, in the mountains,
the realm of all the nature-beings
seems to be much closer
to the world where all we humans dwell.
Amid the mosses and the ferns
I sense the homes of fairy folk
and every passing butterfly and dragonfly and forest fly
portrays an air of mystery and magic.

Here, in the mountains,
I move through time much differently,
more seamlessly, and peacefully,
and it makes me wish
that I could stay forever here.

Here, in the mountains,
I gaze upon a million stars
that hint at what there is to know,
and make me want to seek and grow
and find a way to express it all.

Here, in the mountains,
I feel the presence of Spirit,
so much closer, so much stronger,
more intimate, more immediate,
and more a force within me.
I know, of course, of Spirit's presence
everywhere and everywhen that life exists,
and so it must be *me* that changes.
There is something in this place
that opens wide an inner door,
that in the hustle-bustle world,
I only peek through cautiously.

Here, in the mountains,
is something that can feed my soul,
something which renews my spirit,
something which can make me whole,
each time I visit
here, in the mountains.

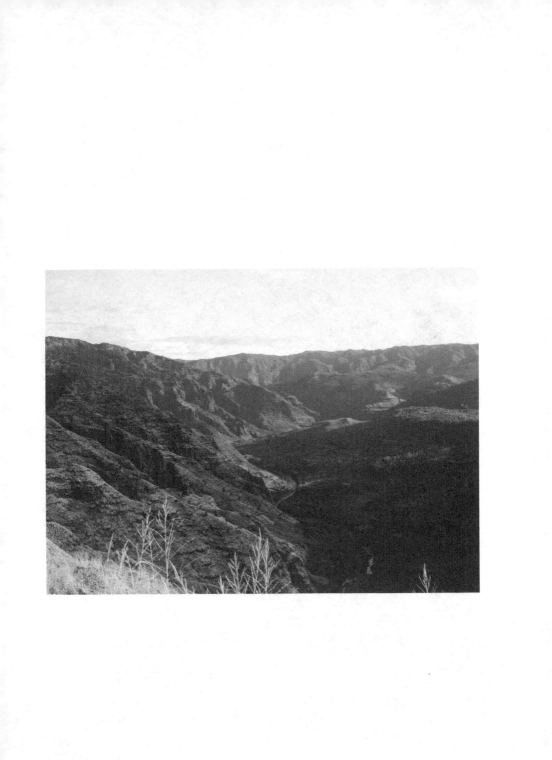

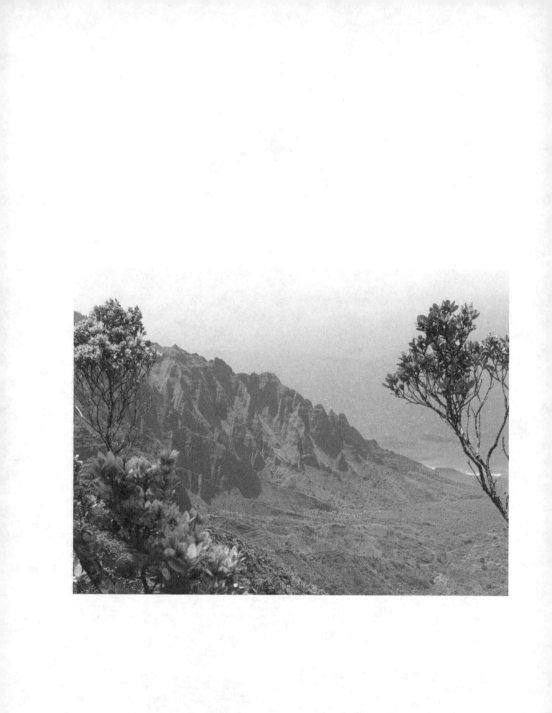

Unmistakable

From the Uplands of Pihea
I stand and gaze down
to the valley below.
The morning air is damp and chill
and I welcome the touch of the sun on my skin.
Green shadows of the Pali lead my eyes
to the lush and mysterious valley below.
As I walk the rim trail, the angles change.
The picture postcard view
becomes a moving scene.
Reaching my favorite vantage point,
I cannot help but smile.
I hear my heart calling out,
"I'm home, I'm here, I've come back."
My mind agrees with the feeling,
but is puzzled.
Not in this lifetime have I lived in this valley,
nor in the uplands of wild Kōke'e
from where I now look down.
Yet unmistakable is the feeling
that here, I am at home.
Unmistakable is the calling to return here,
every time I am too long away.
Unmistakable is the healing that occurs here,
each time I've become frazzled,
or hurt, or overworked, or overwhelmed.
And unmistakable is the wonder,
the beauty, the ecstasy, and the peace,
that fill my being,
each time I am here.

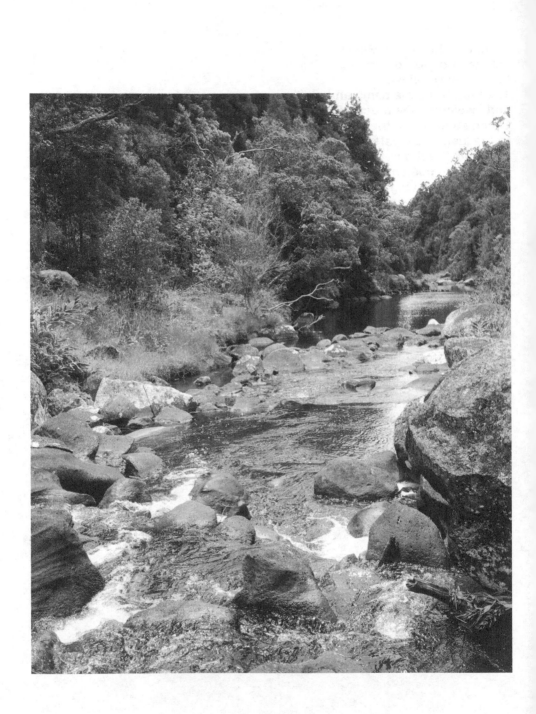

As mankind has moved through time, we have created a multitude of ways of looking at the world around us. Cultures grow and die away, and we explore different ways of thinking, ways of living, and ways of interacting with the world. Vague though our understanding of our ancient past may be, we sense that once we lived very close to Nature, deeply immersed in the wild world and aware of our connections to and dependence upon the rest of Life. As we began to explore in other directions, seeing what our minds were capable of, playing with what we could build and create, we set aside some of our connection to nature in our preoccupation with our own selves and our own culture. While there is nothing wrong with searching out our own abilities, we cannot forget that we are dependant on the planet which supports us. We have reached a point when we need to remember that we are part of a living world. We are not alone here.

It is time to create a new connection to the world of Nature. It is vital to us, and to all of the other life here, that we find a way to live as part of a sustainable pattern. Now it is time for a worldview that incorporates both what we have become as Humankind, and what Nature has become, and most importantly, what our potentials are when we come back together to live in a state of harmony.

It is a step which will ultimately encompass the entire planet, yet it begins on an individual level, one person becoming more aware of and more connected to some small part of nature...and another, and another, and so on from there.

And so, it can begin for you with just reaching out to spend some time really being with Nature. Looking. Listening. Opening your heart to another form of life. The amazing part is how good it feels. Like finally coming home. Welcome back to Planet Earth. How truly blessed we are to be here.

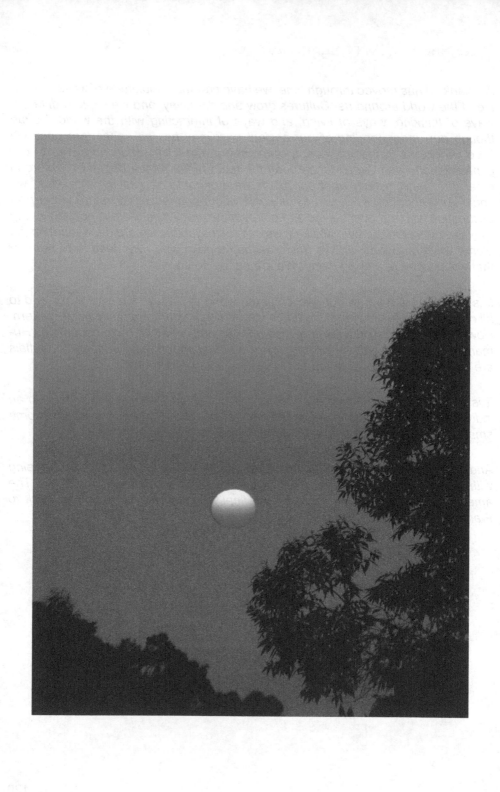

Only One Person

What if all it takes is one person...
One person to greet the sun as it rises in the morning,
so to encourage it to continue its relationship with us,
that it may support our lives...

What if all it takes is one person...
to honor the rising moon,
as it's cycles propel the patterns of our lives,
and brings upon us blessings of beauty and wonder...

What if all it takes is one person...
to acknowledge the passage of the stars,
and the presence of Mystery,
that they may continue to guide and inspire us...

What if all it takes is one person...
to silently give thanks,
so that creation may continue...

Many have forgotten what it means to do this.
I don't know quite how it is so...
but I seem to just know that it is important.
On some days, I am there,
To greet
To honor
To acknowledge
To give thanks.

But on those days when, somehow,
I just cannot be there...

Will it, perhaps, be you?

Claim Your Birthright

You were born upon a living planet;
a multitude of living beings,
dwelling in the midst of elemental powers,
all swirling and flowing and cycling in vibrant life.
And you, human, were born in their midst
that you might interact with them.
Don't shut yourself away in little closed-in boxes,
filled with human-talk and human-thought
and human-stuff alone.
There's a world out there, a real world,
alive and pulsing and filled with delight.
It is your Birthright,
to step into the world of Nature,
to explore and experience and discover
and to connect with those diverse and most amazing beings
with whom you share this world.

It is there for you
to hear the song of the birds who greet the dawn,
to hear the river's tinkling and gurgling as it flows along,
to immerse yourself in cricketsong at the end of the day.

Yours is the privilege
to breathe deeply of the fragrance of forest after a rain,
to inhale the salt air and the smell of hot sand
and the unique scent of sun-warmed skin,
to be enveloped by the intoxicating aroma of a field of flowers.

You have the ability
to let your vision roam
through a dozen shades of forest greens
or an ever-changing array of ocean blues,
or the brilliant panorama of a sunset sky.

Your hands are made to sensitively feel
the touch of treebark, rough or smooth,
the softness of a downy feather,
or the unyielding strength of a granite boulder.

You may delight in the enchantment of taste,
with fresh-picked ripe berries,
or a tomato fresh from the vine,
or the tartness of a lime,
or the super sweet of mango.

It is yours to experience the vibrant life of this world.
The wild world is calling you...listen for it.

Enough of this second-hand passed-down information,
bits and bytes of over-edited someone else's stuff.
Enough of spending so much time in cyber-space,
that your feet don't know how to touch the ground.
You have a right to the Real Thing,
first hand, fresh and new for you,
your very own experience,
one-on-one with the real, live world.

Oh, I know.
They'll give you a million reasons, a million distractions,
to keep you too busy, too involved,
too tied to the human-only world.
For your own good, they'll try to make you think.
But should you look deeper,
their holding you there is usually tied to
their profit, their power, their control.
Find your own balance, your own power,
your place in society and your place with the living Earth.

Claim your time, your heart,
your curiosity, your creativity
and, sometimes, step out the door
to the Wild World, the real world,
the natural world you were born a part of.
It is your Birthright to touch and be touched by Nature.
It is your Birthright to Walk in Wonder.

Be Still

Be Still
What do you Feel?
What do you Hear?

Be Still

What does your Heart Tell You?
What do you Sense around you?

Be Still
In This Moment,
Feeling it deeply.

Be Still

What other forms of Life
Are Sharing this Moment with you?

Be Still
Let your Heart Reach Out.
Let your Heart Receive

Be Still

Feel yourself connected to the Greenworld.
Feel Yourself connected to the Spiritworld.
Feel the way you are all interwoven together.

Be Still.

Green Healing

Its in the very air you breathe,
that moist and fresh and so alive fragrance
that embraces you
when you enter a place of Green-ness.
Here the lines and shapes
are curved and soft,
and you can sink down into them to rest.
There was a time in my life
for sun healing, and sea healing,
and their gifts were many.
But now I crave the Green,
the presence of Tree Beings all around me,
and in the center,
a quiet sunny place with flowers.

Sometimes green healing is
a walk in the woods,
wet bark fragrance,
and the touch of the multitude of mosses.
Or it is standing pressed against
a loving old Redwood tree,
whom I call Grandfather.
Green Healing may come in a fresh brewed tea,
or a spicy herb, or a plant grown for its fragrance.

Yet sometimes,
Green Healing is more ethereal.
It's the feeling of being welcomed by the plants,
into feeling the Oneness that we share.
It is the gift of a brief glimpse
into the Knowing that it is all connected,
even me.
Sometimes Green Healing is going to sit silently,
out amongst the green ones, just to Be.

And every once in a while,
on those most special occasions,
it is feeling some one living part
of our great Gaea Earth,
reach out and touch me with love.
In those times, Green Healing brings to me gifts
that I could not receive in any other way.

Blessed Be the Green.

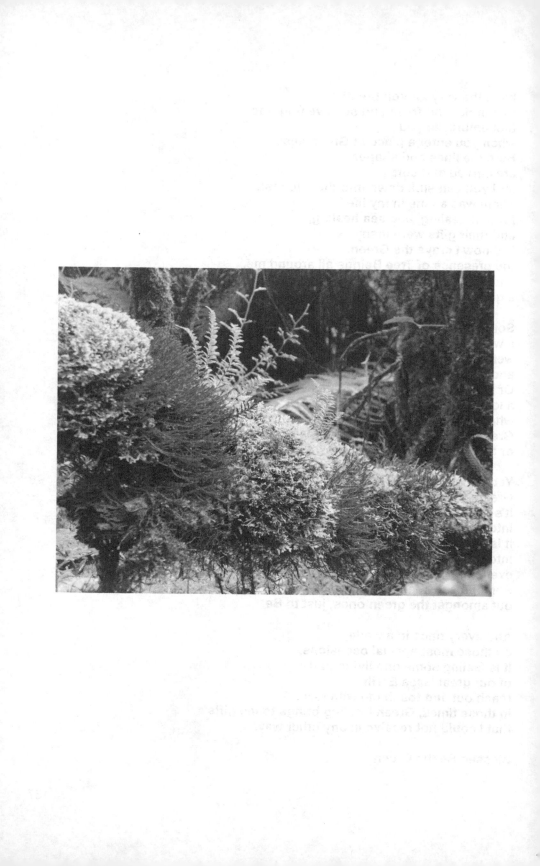

Only by Being with Nature,
Can you Know it.
Only by Knowing it,
Can you Love it.
Only by Loving it,
Can you Protect it.
Only by Protecting it,
by creating truly wise interaction and use of it,
Can you stop the destruction
that has become the habit
of Mankind.

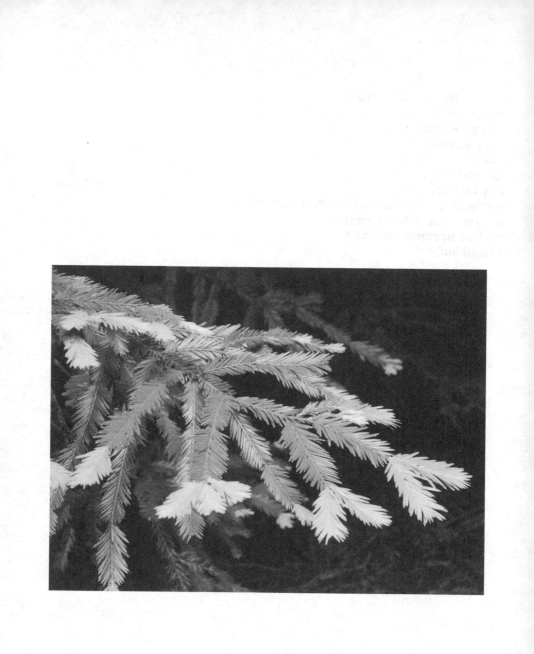

Cycles and Seasons

We live in a world of circles and cycles. The moon circles around the earth, the earth spirals around the sun, the seasons cycle through their pattern.

Life moves in cycles. The tree produces a seed, which becomes seedling, then sapling, then a new tree. Old tree decays to become the minerals and organic matter to feed the new tree and allow it to grow and produce its own seed. Humans too live in cycles, from a baby who needs care to an independent adult who provides care, to an elder who needs care.

Our current Western technological culture, however, encourages us to think in straight lines. Progress is seen to move in one direction only, ever bigger, better, growing, upward moving, climbing, and achieving. Perhaps this is one of the sources of our current disharmony with the natural world. And actually, it isn't a very appealing picture. For with this worldview, we set ourselves up to climb a ladder where we must keep climbing, and climbing, and climbing, until what? Until we are exhausted and "fail"? Until we get to the end of the ladder and fall off the top and die?

Personally, I prefer Nature's system of circles and cycles, achieving and resting, working and playing, flowing around and around and around.

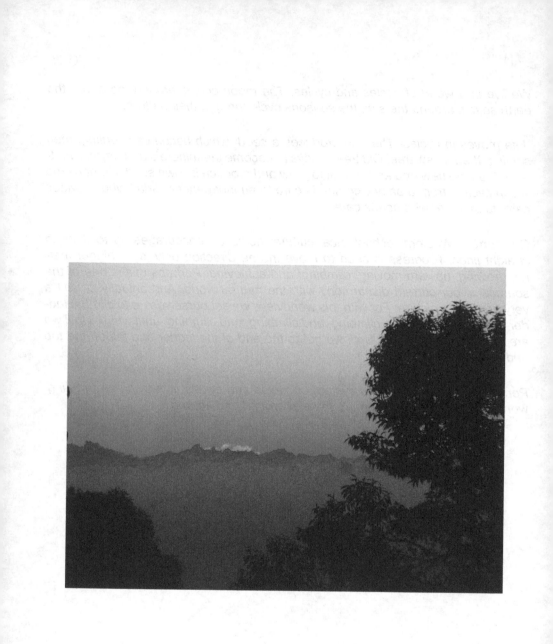

The creation of the Elements

Long, long ago
before time as we know it,
the One Who Is All
began to laugh,
and began to play
with different ways of Being-ness.

And so there came into being
the Element of Fire.
Light and Heat and Flame swirled and danced,
and so movement was born,
and stars were formed,
and the Creator Of All felt delight.

Seeing the ethereal nature of fire,
the One Who Is All began to ponder
what qualities might lie in the other direction,
something with weight, and solidness, and strength.
And so there was created hot molten lava, and solid stone,
and the planets were born, which began to dance around the stars.
Stone shaped itself into mountains and valleys,
sharp peaks and rounded hills, and all manner of textures and shapes.
And stone became also soil and sand
and all together they comprised the Element of Earth.
And the Creator looked upon all this variety
and was pleased.

By and by the One Who Is All
began to wonder what it would be like
to wander and play in a form that could feel and caress
all these wondrous textures and shapes.
So then there were created two more Elements.
On the ethereal side was Air,
drifting lightly above the earth,
traveling, exploring, swirling,
and creating beautiful and ever changing patterns.
The other Element took a more dense form,
and became Water.
Water too delighted in changing her forms,
and became mist and dew, streams and rivers,
rain and ice and oceans.

As wind and water played upon the earth,
they were heated and cooled by the touch of fire,
and this increased their movement.
With this movement they learned they could create sound,
and many and varied were the songs they devised
to delight the Creator.

Ages passed, and in the mind of the One Who Is All,
the potentialities of what had been created here
began to take form.
And the Creator said to the elements,
"With the four of you working together with me,
endless are the possibilities of what we might create.
I will add to the four of you a fifth force,
the breath of my Spirit,
and together we shall create a garden,
of wondrous diversity and amazing beauty.
And so were all the beings of nature formed.
There came into being all manner of plants;
mosses and lichen, ferns and grasses, herbs and trees,
and in each of these were endless varieties.
Countless were the days when the Creator must have said,
"Now what new thing shall I create today?"
And perhaps in that day would be born
a fern that grew as big as a tree,
or a flower that floated serenely on a pool of water.
Likewise were the animals created,
from snails to elephants, lizards to dragonflies.
And to each of these new beings the creator gave gifts,
skills and talents, properties to heal and nourish each other.
And together they were bound in intricate connections,
in cycles that revolved through seasons of heat and cold,
and in cycles that revolved through birth and death.
They were woven in patterns together,
that they might sustain each other
and provide for their continued existence
and their evolution into ever new variety.

And the One Who Is All delighted in this Garden,
feeling the essence of plant-being
lifting green leaves to the warmth of sun
and bringing forth sweet ripe fruit.
And feeling also the essence of animal-being,
burrowing through soil as earthworm,
circling over prairies at twilight as owl,
swimming through salty seas as a great whale,
singing deep songs that traveled far and wide.

And ages passed,
and ever more wondrous became the Garden.
And the One Who Is All saw how Life supported Life,
and the patterns were beautiful to watch.
By and by the thought formed in the Creator's mind
of yet another level of creation.
Even as the Elements supported and sustained the life of plants and
animals,
and they helped to support one another,
so then could all of these beings now created
support another race of beings.
And the thought came to the One Who Is All
of giving these new beings even more creative power
than had been given to the others.
For the Creator does indeed love variety,
and longed to see what they would devise.
And the One Who Is All mused,
"Here indeed will be yet another form
in which I can experience the wonders of this world.
And when they have matured to their full stature,
I will come and walk within them.
And great shall be the wonders that arise in that age."
And so was humankind brought forth,
and they were given the gift of the Spoken Word and Focused Intention,
with which they could create great things.
And humankind were placed in the garden,
and bound to the cycles of life
that supported all of the other beings dwelling there.
For in being so bound,
they could learn respect and cooperation.
And in being so bound,
they could be provided for, given sustenance and nurturing.

Being so bound
they could feed their spirits upon the endless marvels
and wonders of their world,
learning bit by bit the essence of their Creator.
The animals could teach to humankind their skills and talents.
The plants could bring to humankind their healing qualities,
and the ability to delight in life.
The elements could bring to the new ones
an understanding of the building blocks of life in this world,
and how to create balance.
All humankind need do,
was to go and play among them,
to dance with wind and float with water,
to sing with trees and soak up sun among the flowers,
and listen carefully to all that the beings of this world have to teach them.

And you, human one, you now reading this story...
Are you enjoying the gift of life which has been given to you?
Do you go to listen to water and wind,
and to learn from fire and earth?
Do you walk among tall trees and take counsel with them,
and listen for the messages of the birds?
Do you go to the wilderness when you are disturbed,
so that you might be nurtured and healed?
For thus it is that you will attain the wisdom, the balance,
and the joy of life.

The One Who Is All
seeks to dance ever more fully within you.
Will you allow it?
Will you grow into Who You Can Be?
Are you ready to live your true place in creation?

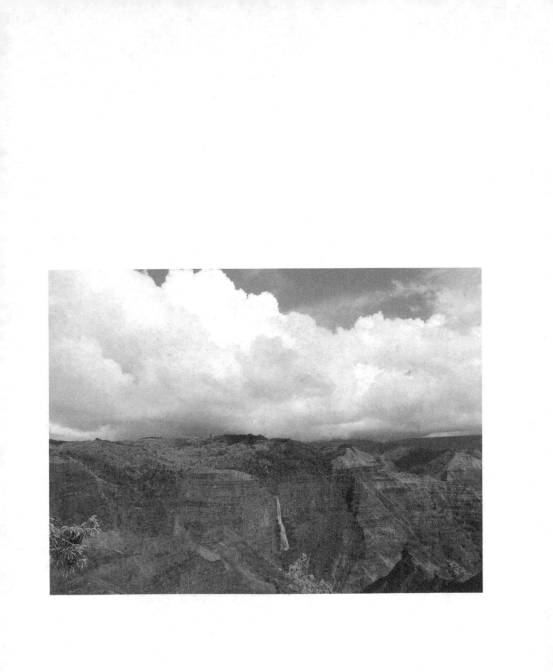

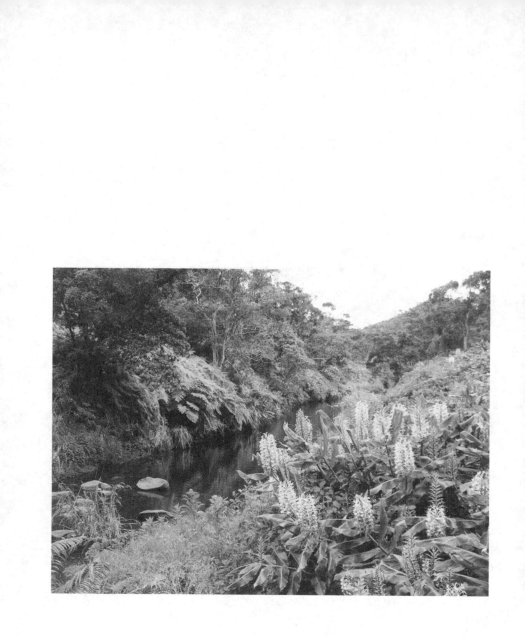

Being

We have forgotten how to Be...
To lie perfectly still and let the wind play over your body,
 smoothing out the tensions...
To listen to the sound of the sea rolling down the shore
 washing away worry or sadness...
To breathe in the fragrance of a flower
 until it fills your lungs
 and you begin to connect with its essence...
To watch clouds move against a blue sky,
 or patterns of sunlight and shadow against a green mountain...
To take time to ponder, "Who am I really?" and
 "Who do I really want to be?"
To spend a day just being still enough to listen
 to what Spirit may have to say to you.

We live in a society that bombards us with the drive to "do,"
to cram a million bits of activity into every day,
to use every second for something verifiably "productive"
and if possible, to do two or three things at once.
But where did this come from?
Whose idea was this?
Doesn't anyone consider that this may be unwise?
Haven't they seen that all this excessive doing
produces stress, anxiety, tension, exhaustion,
illness, anger, and even feelings of guilt?

Surely as human beings we are capable of better lives than that!
We need to learn again from our brothers and sisters,
the plants and animals,
how to live in this world.
We need to remember that time flows in cycles and seasons,
and that relaxation and renewal can balance action,
that laughter and play can balance concentration and work.

And then we may rediscover that true inspiration and creativity
can come to us only when we are still enough to listen,
not preoccupied with an endless rush of doing-ness.
We are in need of renewal.
Our world is in need of healing.
Will we slow down in time to hear the answers?
Will we remember how to Be
and again become a part of this world?

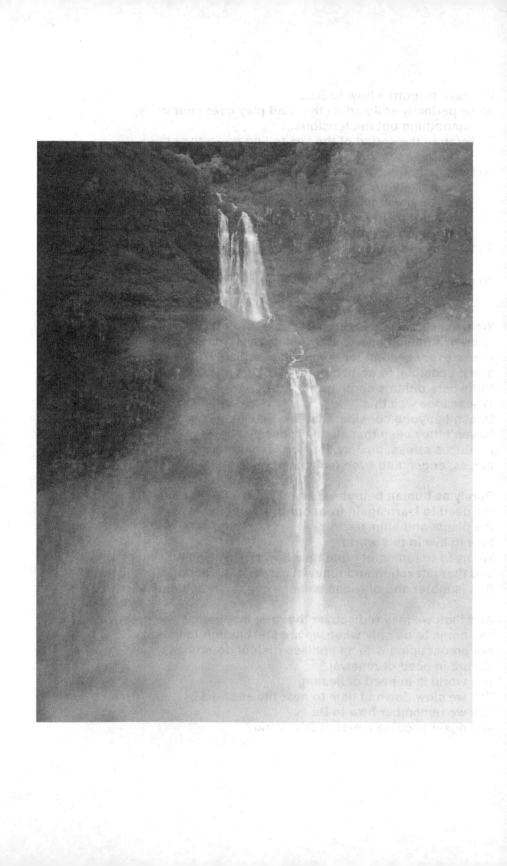

Out with the Elements

Rain and Sunshine,
Sunshine and Rain,
Wind and Stillness,
Stillness and Wind.
Soft Earth holding all
with strength and serenity.
These are there always,
cycling around and around,
nourishing the life of all creation with love.
All else matters little
unless we live in harmony with these.
For it is through these elements
that Spirit does support
the lives of all that lives.

Succession

It must have been during the torrential rain just past,
that grandfather at last lay down to rest,
huge limbs spread now along the ground,
still arching and curving,
as crescent leaves begin their slow descent into soil.

The Apapane bird still sings here,
perhaps in tribute,
a sending-off filled with memories
of shared days of happiness.

Just there, where he stood for all those long days,
is a new patch of sunlight,
a vision of blue sky,
and the yet unanswered question
of who will come now,
growing strong and majestic,
to preside over this peaceful forest.

(The king is dead, long live the king.)

The Tiniest Droplet

The tiniest droplet, barest whisper of water,
hangs in the air in the mist that swirls
around the highest places of the mountain.
Slowly it drifts, carried on the breeze,
over lush valleys,
winding among the trees of the forest.
Other droplets gather near,
then a few more.
The little droplet seems to draw a deep breath,
and sighs happily to herself,
thinking, "Yes, it is time."

Together the gathered droplets land softly on a leaf,
and begin to slide along
down twig and branch and trunk
until they reach the ground.
Many droplets have now come together
in the ground at the base of the trees.
It is time to change from swirling mist
to form a flowing streamlet.
"This will be fun,"
thinks the tiniest droplet.

The droplets of water begin sliding downhill.
They wiggle between stones,
and slide over fallen leaves.
Some of the droplets let themselves
soak up into a bed of soft moss,
but others keep going,
heading for the nearest stream.
The tiniest droplet sways and flows,
and laughs at the feeling of moving as liquid.
They know where to go: downhill.

Swirl and flow,
leap and dance,
slide and wiggle,
tumble and roll,
they laugh their way down small cascades
and sing as they slide into still pools.
Sparkling in the sunlight,
dreaming in the moonlight,
ever they move on and on and on.

"Welcome."
The deep voice startles little droplet out of her daydream.
"Look," whispers the droplet next to her,
"We have reached River."
Deeper and wider than the small stream,
River is slow moving and stately.
As little droplet eases her way into River,
she thinks to herself,
"Now I feel majestic and beautiful."

The tiniest droplet lived in River for a long time.
It was peaceful being River.
Sometimes little droplet would let herself sink
deep down into a wide pool
where it was quiet and almost still.
Sometimes she would sit on the surface
and let the sun reflect off her back,
making silver sparkles.
Little droplet learned that many forms of life
depended on River in order to live.
Some lived within the river itself,
and others lived along the shores.
Some of the droplets chose to go
and participate in these adventures,
such as letting the tree roots drink them up,
or giving a small bird a bath.
The tiniest droplet chose to stay within River,
and her favorite time
was when she had a chance
to slide over a large boulder
and sing as she dropped into the water below.

One day little droplet heard a strange, deep sound,
a rumble that repeated itself over and over
in a soothing sort of way.
Around her the other droplets began to whisper,
"We're almost there."
Then as River made a final turn
she saw before her the Sea.
The Sea was beautiful,
made of many shades of blue and green
with patterns of waves on the surface.

Little droplet watched with amazement
as waves of water swished themselves up the shore,
then suddenly reversed direction
and slid back down into the sea again.
That was to be only one of the many adventures
that awaited the little droplet in the sea.

She settled into her new life,
dove down deep to meet fish and corals,
traveled along beautiful beaches,
listened to the songs of the whales,
and helped to hold up boats
for the fishermen and the divers.
When it was Full Moon,
the tiniest droplet loved to go up to the surface,
to see the way the moonlight
made the water look like it was liquid gold.

One hot summer day,
the tiniest droplet was sunning herself on the surface of Sea,
when she heard someone whisper to her.
The voice seemed to come from above her,
and as she looked up the sun repeated
what he had said to her.
"Are you ready?"
"Am I ready for what?" asked the little droplet.
"Why, to do it all again! " replied the Sun.
"Well, I'm not quite sure what you mean,"
said the droplet tentatively,
"But I'm willing to give it a try."
Suddenly little droplet felt herself
being lifted up and up and up,
becoming lighter,
and feeling like she was almost
becoming a part of the air.

She was, in fact, turning into water vapor,
and about to become part of a cloud.
The cloud drifted with the wind,
away from the ocean, over the land,
and up and up to the mountaintop.
The tiniest droplet looked down,
and there before her was the forest
where she had long ago turned
from drifting mist into a drop of rain
and started her long journey.
"I remember this," said the tiniest droplet happily,
"I've come home."
The little droplet looked around,
enjoying the view of the mountain forest below her.
"I will stay here for a while," she mused.
"But then, yes," she giggled,
"I think I will do it all again."

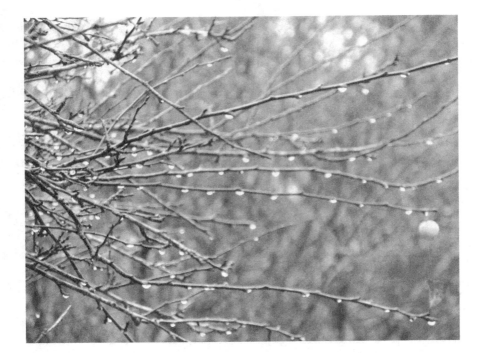

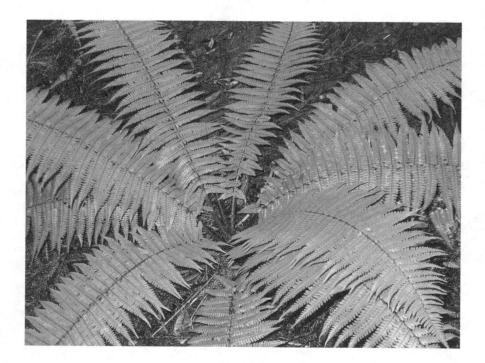

Circles of Life

A Circle of Earth
that turns for its days
is circled by Moon
who dances and plays
while together they circle
to orbit the Sun
in a year full of Seasons
we feel one by one.
And on the Earth
circles are danced day by day
by life that is born
and then passes away,
to circle around
through the elements' care
to another new life
that will come who knows where,
for another adventure
of living on Earth
who dreams us in circles
from death into birth.

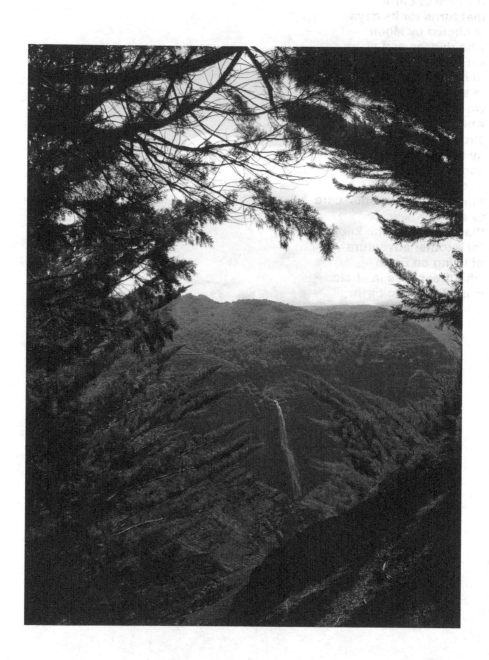

On our Earth-home

Spirits that dwell in the Mountain
Spirits that dwell in the Sea
I have come seeking your guidance
Will you now come speak to me?

Long have you dwelt on our Earth-home
Building the cycles of Life
Much I am sure you could teach me
I come to seek your advice.

I too am born of this Earth-home
Though my people have wandered astray
Yet the hope remains that we awaken
And return once again to our way.

For the Spirit of One dwells within us
As the Spirit dwells also in you
May we open our hearts and find wisdom
That our path on this Earth-home be true.

There is a way of Being in which Mankind and Nature
live in right relationship, recognizing their true connection.

Included in this relationship is our connecting to various aspects of Nature
for healing, for energizing, for emotional well being, and for deepening our
spiritual connection.

Included in this relationship is learning ways
we can live more harmoniously with Nature,
and assist her well being as well as our own.

The bonding of Nature and Mankind is a sacred connection.

It is a connection that can heal the Earth.

It is a connection that can heal Mankind.

When there exists between them a state of Respect and Honor,
of Cooperation and of Love, then will there be a time
when we can begin to live our true destiny.

This is my goal:
to bring harmony, healing, love, and a new sense of wonder to the
relationship between Humankind and Nature.

There is a way of Being in which Mankind and Nature
live together in ecstasy.

In Closing....

Layer upon layer upon layer of experiences with Nature have so deeply touched me, so shaped my life, that I find myself viewing this relationship as one of the most important in my life. In searching for a way to define who I really am, aside from whatever I happen to currently be doing for a living, I find the most appropriate description to be that I have become a "Nature Mystic." You need not, of course, enter Nature's world as deeply as I choose to do. Even small connections with Nature bring gifts and benefits to us. I do hope that you will reach out to Nature yourself, and find the particular wonders and joys that she holds waiting for you.

Of all the messages and ideas I have gathered from time spent with Nature, the one I feel is most important, is to look at what our relationship with her could ideally be. A great potential lies ahead of us when we as humankind once again open our minds and hearts to Nature's presence and begin to live more cooperatively with her on this planet which we share. I've taken this thought as a sort of long range purpose statement, that this is what I hope to work toward, for myself and in guiding others. I hold the dream that this "Way of Being" is what we are evolving into.

'Apapane A Hawaiian honey creeper (Himatione sanguinea)

'Aumākua Family or personal gods, deified ancestors who might assume the shape of certain animals. A symbiotic relationship existed; mortals did not harm or eat 'aumākua, and 'aumākua warned and reprimanded mortals in dreams, visions, and calls. In more recent usage, may refer to the eternal part of one's being, the 'Higher Self'.

Hina A goddess (often associated with the moon and with water)

'Iwa Frigate or man-of-war bird (Fregata minor palmerstoni); it has a wing span of 12 meters.

Kai Sea, sea water, area near the sea, seaside

Kalalau A valley on northwest Kauai, uninhabited and difficult of access.

Author's note; There is a difficult trail along the Napali coast leading to Kalalau, and it can be seen from above from the Pihea trail or Pu'u o kila lookout.)

Koa The largest of native forest trees (Acacia koa)

Kōke'e * An area in the mountains of Kauai and name of the state park there.

Lapa-lapa Native mountain trees (Cheirodendron in the panax family) conspicuous for the slender-stemmed leaves... that flutter in the breeze.

Mahalo e ke Ualani Mahalo- thanks, gratitude
(*Mahalo e ke Ualani - Thank you, heavenly rain.)

Māhealani Sixteenth day of the lunar month, night of the full moon

Mahina Moon, month, moonlight

Makani	Wind, breeze
Mana	Supernatural or divine power, miraculous power, authority, to have power, authorization, privilege, spiritual.
Noe	Mist
ʻŌhiʻa	ʻŌhiʻa Lehua, (Metrosideros macropus) The plant has many forms from tall trees to low shrubs
Pali	Cliff, precipice
Pihea *	An area in the mountains of Kauai.
Pinao	Dragonfly
Pueo	Hawaiian short-eared owl (Asio flammeus sandwichensis,) regarded often as a benevolent ʻaumākua
Ua	Rain
Wai	Water, liquid or liquor of any kind other than sea water.

Definitions taken from Hawaiian Dictionary by Mary Kawena Pukui & Samuel H. Elbert, University of Hawaii Press.

Most Hawaiian words have many meanings. I give the one applicable to my use in the poems.

Words with * are defined by common usage.

In Memory of David Boynton

Not many men these days walk in tune with the spirit of the forest, their sense of wonder open to receive the ever changing marvel of nature. David was one of those who did, able to sense the delight in a shade of color or the shape of a stone. Yet what made him even more unique was his ability to share these experiences with others, showing them how to look at nature with new eyes and an open heart. So many, many classes of students have been awakened to nature by his teaching and his example. So often his photographs have deeply touched a heart, showing someone how to notice the beauty they had passed by un-seeing. I can almost see his spirit flying now over previously in-accessible mountains and valleys, and for a fraction of a second thinking, "Oh, I should have my camera." And I know at least one trail in the forest which will miss his caring touch, where he led students in pulling out weeds to give the native plants room to grow.

My heart, along with so many others, along with the trees, the ferns, the ridges and hollows of the mountain, along with Laka, the goddess of the forest, all sigh and say, "We miss you, David."

He did so much for Kaua'i. I wonder if he knew how much we appreciated him. Now his empty shoes are too big for any of us to fill. But perhaps, if we each do a little, taking the time to sense and appreciate nature's creations, teaching a child to pause in the woods to look and listen, sharing with a friend an image from some magical moment of nature's beauty, or putting together a few words to draw attention to the absolute wonder found in wild places, then perhaps then we can carry on the work which David did so brilliantly, and for which we are so grateful.

Mahalo nui loa, David.

(David Boynton was a well-loved naturalist, environmental educator, and nature photographer who spent much time in the Kōke'e environment of Kaua'i.)

About the Author

Kapua has explored a variety of paths in this world, and throughout all of them her greatest delight has been to find ways to weave nature into her life. She has taught school, worked on ships, performed music at exotic resorts, been a professional massage therapist and Lomi-lomi massage instructor, and studied in the areas of spirituality and shamanism.

In order to guide people in experiencing and appreciating some of Nature's special moments, she has facilitated Full Moon and Solstice celebrations. She designed a radio program focused around topics, prose, and poetry about nature, interwoven with nature sounds and New Age music, which was aired on a PBS station for five years. She has also produced recordings of original music featuring the sounds of natural environments varying from the rain forest of Tortola to the seashore of Sanibel Island. She wrote a weekly article for "The B.V.I. Beacon" for a year, which talked about current happenings in nature and encouraging people to go out and experience it.

Now living on the island of Kaua'i in Hawaii, she spends much time on the trails and in the forest, especially in the mountain area known as Kōke'e. Nature frequently inspires her with bits of poems or prose, images of beauty to photograph, and an assortment of delightful, unexpected wonders.

As for defining who she is, she tends to prefer the term "Nature Mystic," which she defines as "someone who spends much time in Nature, seeking those moments of deep connection, where you feel your oneness with the Spirit in all that is."

Kapua may be reached at Whispersonthemountain@gmail.com

Looking back, I can see that many things were involved in leading me to write this book, though I may not have been aware at the time of where I was eventually headed. For as long as I can remember I have been drawn to the places of Nature's beauty and wildness. While most of childhood is a barely remembered blur, I remember quite distinctly the day my Mother showed me a redwing blackbird among the cattails at the small "forest preserve," the closest we could get to nature in our city environment. I also remember visiting rural cousins, and the wonderful discovery of crickets and fireflies. When I entered my working years, I immediately left the city and sought out an environment with more of Nature's presence. My "days off" existed solely for the purpose of being somewhere outdoors. Before long I discovered that I liked living on islands, and my nature time was spent exploring uninhabited beaches and shorelines and the sea itself. Eventually, on an island halfway down the Caribbean, I discovered mountains as well, and a whole new world of nature's wonder opened up to me.

As my time in wild natural places increased, I began to notice that often Nature would have things to say to me. That is, I'd be sitting there surrounded by Nature's presence, enjoying the serenity, and suddenly there would be words and images and thoughts in my mind that weren't there a moment before. The odd thing was that it did not seem like I was the one putting them together. It felt more like I was taking dictation for Gaea, for Mother Earth, who was saying, "Here, write this down. Capture this moment, this beauty, the essence of this place." I began to make certain that I always carried paper and pen on my outings, and later transferred my scraps into notebooks.

At one point an unexpected opportunity gave me a chance to produce a weekly radio program for a PBS station. I decided that between the selections of music I would focus on Nature, reading poems and prose and interesting tidbits, with the intention of creating an image of Nature's amazing beauty. I assumed there would be much material available, given my own experience with all of Nature's inspirations. I found some wonderful collections of the writings of those who had been deeply touched by nature. Here were the classics, such as Henry David Thoreau, Wendell Berry, John Muir, and Gary Snyder. But as I searched for material, I found that much, if not most, of our nature writing seemed to be done from a primarily "left brain" focus. Most of it consisted of scientifically focused studies, or reporting which lamented some environmental issue. These were important, of course, and I dedicated some programs to such topics. But I was looking for something beautiful, something to inspire people with the wonder, the amazing feeling of being surrounded by Nature's presence. I wanted something poetic. I found that much of poetry, these days, had turned to complaining and venting anger and seeing how weird and abstract one could be with words. So I began to pay closer attention to

the images and messages I was myself receiving from Nature, and saving them for future reference.

In the middle of the Pacific Ocean, the small island of Kaua'i captured my heart and called me to come to her. In particular I was drawn to the mountain area known as Kōke'e. Here Nature provided moments of beauty and laughter, companionship and comfort, healing and spiritual connection. Here, more than ever, Nature whispered to me, and said "Put this in a form you can share." And, more than ever, I began to feel that this was important. Over the years I have seen, and I feel that Nature too has noticed, that far too many people are hardly aware of Nature's existence at all. They are cut off, preoccupied, stressed out, distracted, frazzled, and ignoring one of the things that could be of the greatest benefit to them: time spent with Nature. More and more it seemed that Nature was telling me that we needed something to draw our human attention back to her, back to the connection that would make both of us well and balanced once again.

And so, at last, I have begun to gather together those most special moments that Nature has shared with me. And I have begun with those experiences she has given to me, and those wisdoms she has whispered to me, here in Kōke'e, on the island of Kaua'i, here on the mountain. May they provide the inspiration that leads you to seek out Nature's wild, wonderful, and delightful presence for yourself.

CPSIA information can be obtained
at www.ICGtesting.com
Printed in the USA
FSOW03n1520300316
18633FS